The Eads Bridge

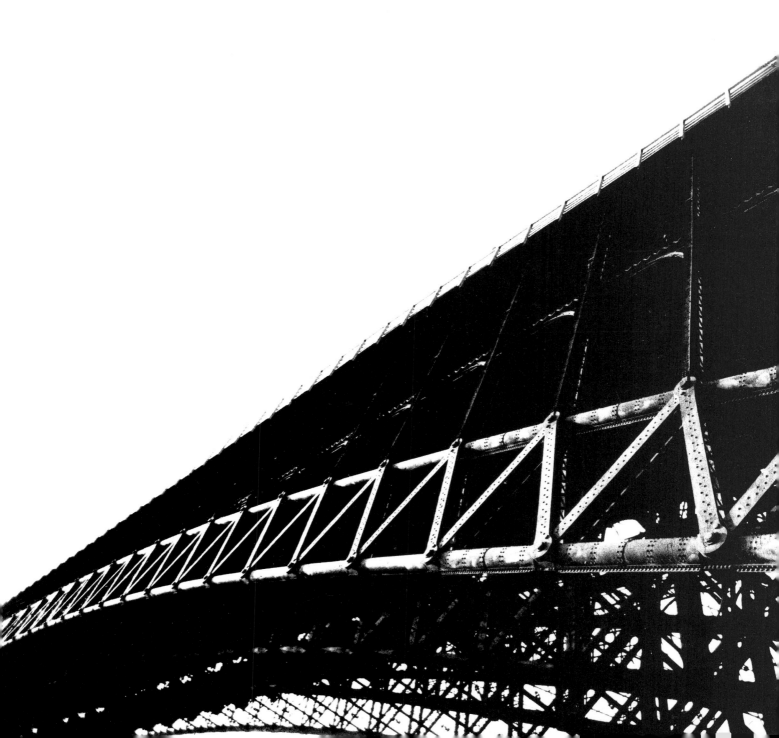

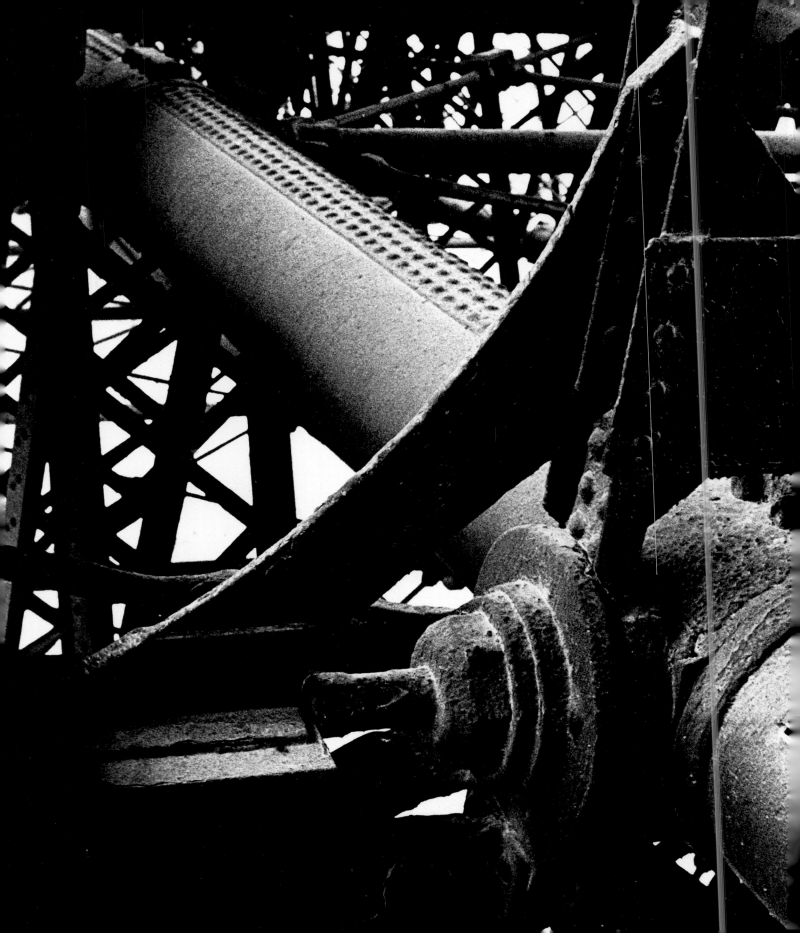

The Eads Bridge

Text by Howard S. Miller
Photographs by Quinta Scott

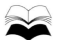

Missouri Historical Society Press
Saint Louis
Distributed by University of Missouri Press

© 1979, 1999 by Howard S. Miller and Quinta Scott
All rights reserved
Published in the United States of America by the Missouri Historical Society Press
P.O. Box 11940, St. Louis Missouri 63112-0040
03 02 01 00 99 5 4 3 2 1

Second Edition

Library of Congress Cataloging-in-Publication Data

Miller, Howard Smith, 1936–
 The Eads Bridge / text by Howard S. Miller ; photographs by Quinta Scott. —2nd ed.
 p. cm.
 Previous ed. by Quinta Scott.
 Includes bibliographical references and index.
 ISBN 1-883982-29-4 (cloth : alk. paper)
 1. Bridges—Missouri—St. Louis. 2. Eads, James Buchanan, 1820–1887.
 3. Saint Louis (Mo.)—Buildings, structures, etc.
I. Scott, Quinta, 1941– . II. Scott, Quinta, 1941– The Eads Bridge. III. Title.
TG25.S15S36 1999
624'.67—dc21
 99–17885
 CIP

Distributed by University of Missouri Press

Printed in Canada by Friesen Printing

∞ The paper used in this publication meets the minimum requirements of the ANSI/NISO Z39.48-1992 (R 1997) (Permanence of Paper).

Illustrations reprinted from the following sources:

Eads Bridge Collection. Washington University Archives. St. Louis, Mo., by permission of the Terminal Railroad Association, page 93.

Engineering 6 (16 October 1868): 344, page 77.

Keystone Bridge Company, *Examples of Structures Built by the Keystone Bridge Company* (Pittsburgh, n.d.), page 126.

Mercantile Library Association, St. Louis, Mo., page 125.

Missouri Historical Society, St. Louis, Mo., pages 60, 64, 76, 81, 85–7, 95–9, 105–6, 108, 112–18, 120–21, 123–24.

Quinta Scott, pages i, ii, ix, x, xii, 3–58.

I have haunted the river every night lately,
where I could get a look at the bridge by moonlight.
It is indeed a structure of perfection
and beauty unsurpassable, and I never tire of it.

<div style="text-align: right;">WALT WHITMAN</div>

Contents

xi	Foreword by Robert R. Archibald
xiii	Preface
xv	Acknowledgments
1	Photographs by Quinta Scott
59	Text by Howard S. Miller
135	Index

Contemporary Photographs

i	North side of west span
ii	Detail, joining of train-deck floor beam, knee braces, and main braces at sleeve couplings
ix	South side of the Eads Bridge from Illinois shore
x	Detail, upper ribs, south side of the east span with MetroLink
xii	West approach to train deck with MetroLink
3	North side of the Eads Bridge from the Illinois shore
4	West span
5	Detail, wind-truss bracing, center span
6	North side of the east span from the Illinois shore
7	East approach to the train deck
8	North side of the east approach
8	Detail, south side of the east abutment
10	North side of the east approach and abutment
11	Detail, interior arcade, east approach
12	East abutment
13	Detail, lower rib and skewback plate at the west abutment
14	Detail, lower rib and skewback plate at the west abutment
15	Detail, upper and lower ribs and skewback plates at the west abutment
16	Detail, underside rib joint showing the joining of sleeve coupling, main brace, and horizontal stays
17	Detail, lower rib and skewback plate at the west abutment
18	Underside of the west span at the west abutment
19	South side of the bridge from the Illinois shore
20	South side of the center and east spans from the Missouri shore
21	Detail, upper rib, south side of west span

22	Detail, wind-truss anchorage bolt
23	North side of the train deck from the east pier
24	Detail, upper ribs, south side of the west span
25	Detail, upper ribs, north side of the west span
26	Detail, keystone sleeve coupling, upper rib, center span
27	Detail, ribs and main braces, center span
28	Detail, joining of sleeve couplings, horizontal stays, tension rods, and road-deck bracing, center span
29	Detail, joining of train-deck floor beams, knee braces, and main braces at sleeve couplings
30	Detail, skewback plates and main braces, west span at west pier
31	Detail, wind-truss and road-deck struts, west span
32	Detail, horizontal stays and tension rods, underside of west span
33	Detail, skewback plates and main braces, west span at west pier
34	Detail, main braces, center span
35	Detail, upper and lower ribs, center span, east pier
36	Detail, main brace and train-deck support, center span
37	Detail, joining of main braces and train-deck support at sleeve coupling
38	Detail, joining of sleeve coupling, main braces, horizontal stays, and tension rods
39	Detail, joining of sleeve coupling, main braces, horizontal stays, and tension rods
40-41	Silhouette, center span
42	Detail, sleeve coupling
43	Detail, joining of main braces at sleeve coupling, west span
44	North side of west span
45	Detail, decorative arches supporting horizontal bracing
46	Detail, diagonal bracing of road-deck struts
47	Detail, diagonal bracing of road-deck struts
48	Detail, diagonal bracing of road-deck struts
49	South side of train deck from west abutment
50	Detail, wind-truss anchorage bolt
51	West approach to bridge from tunnel
52	West approach to the west arcade from the west abutment
53	South side of west approach
54	Detail, south side of west approach
55	Detail, south side of west approach
56	North side of Eads Bridge from Missouri shore
57	North side of river piers from Missouri shore
58	Eads Bridge from upstream

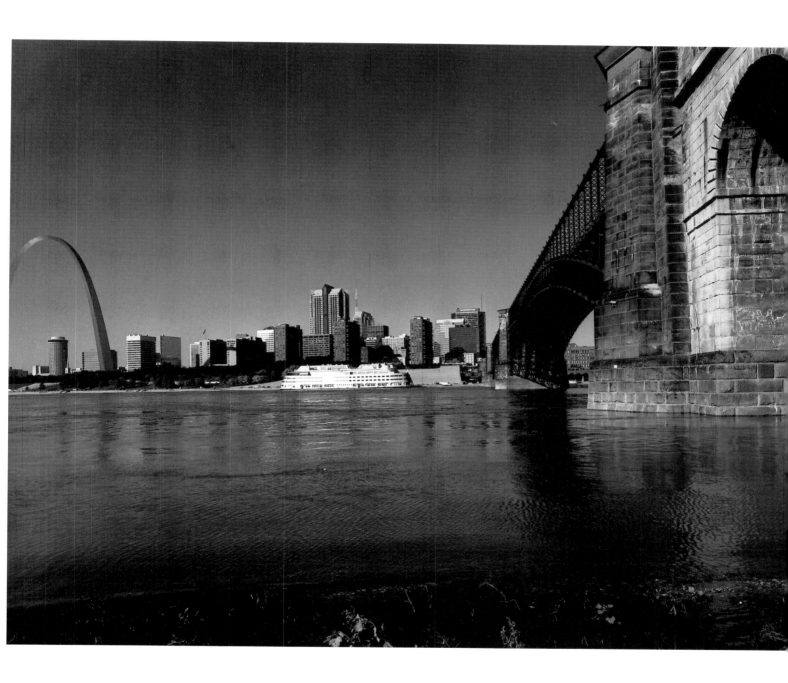

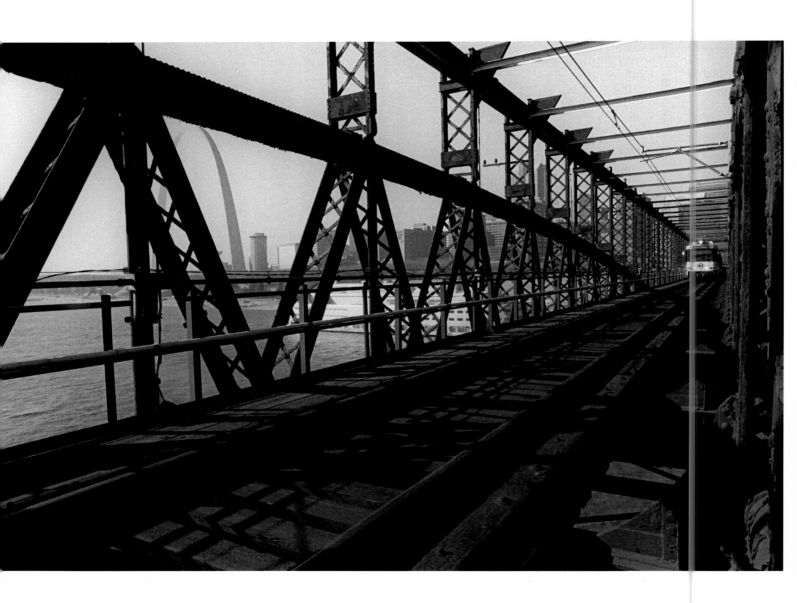

Foreword

As the Missouri Historical Society Press prepared the second edition of *The Eads Bridge*, the bridge and its future were the subject of debate and dissension. Perhaps that is fitting; from the very first discussions of bridging the Mississippi at St. Louis, the topic and its associated themes have generated conversations of both admiration and animosity. This second printing of *The Eads Bridge* will surely provoke admiration and hopefully some conversation, but hardly the animosity, that the construction of the bridge did more than a century ago. No matter how widely opinions of the structure differ, the bridge has endured as a symbol of our civic culture and as a model of engineering, art, and innovation throughout its 125-year history, across the nation and in St. Louis.

I like to look at this wonderful structure in various lights and from different perspectives, but I am loath to see it crumbling, as though it were merely old stone, without story and without a share in the future. The Eads Bridge has been a commercially viable connection between Illinois and Missouri, between the East and the West, between commerce and customer. Yet it has also been a symbol of division: steamboat versus railroad, politics opposing progress, East *against* West. While the bridge still speaks to the divisions between us, it is also a monument to things past and present that unite us, reminding us what we have done well and symbolizing the resources we can use to create future successes.

Quinta Scott, with her excellent photographer's eye and her daring and imaginative approach to the familiar structure, created a portrait that is both spectacular and intimate, while Howard Miller's masterful essay takes us once again through the intriguing story of the bridge's design, engineering, and construction. It is a pleasure and also a long-delayed honor to offer *The Eads Bridge* to the admirers of Quinta and Howard's work—and of course to the fans of the magnificent bridge.

Robert R. Archibald,
President, Missouri Historical Society

Preface

At the dedication of the St. Louis Bridge in 1874 James Eads declared that it would endure "just so long as it continues to be useful to the people who come after us." A century and a quarter after Eads built the bridge, and two decades after we first published this book, it is gratifying to know that the public still finds both useful. The bridge remains a vital link between the east and west halves of the St. Louis metropolitan area. The book remains in steady demand, prompting the Missouri Historical Society Press to issue this new edition.

Except for several new photographs and minor copyediting, the book remains the same as the original hardbound edition published in 1979 by the University of Missouri Press. Eads Bridge then faced an uncertain future, and the book was something of a tribute, something of a requiem. The last train had crossed the lower deck in 1974. By the late '70s vehicular traffic on the upper deck hardly paid the tollkeepers' wages. Abandoned by the railroads, now deserted by cars and trucks, the bridge no longer served a vital function or paid its own way. A rusting relic of another age, it hung in historical limbo, too expensive to keep up or tear down, and familiar enough to ignore.

The beginning of MetroLink regional light rail service across the refurbished lower deck in 1993 brought Eads Bridge back to life. Thousands of riders daily discovered or rediscovered the engineering and architectural monument in their midst. Heightened public awareness piqued curiosity about plans for replacing the upper deck, gone since 1991.

By late 1998 mounting debate over proposed new upper-deck designs showed that St. Louisans still cared intensely about the old bridge as a regional transportation link, civic amenity, and urban icon. As this edition went to press, local papers carried Eads Bridge feature stories, notices of public meetings, and lively letters to the editor. James Eads's prophecy still held; the bridge endured.

Historical interest in Eads Bridge never waned. During the years since 1979 scholars have added important details to the Eads Bridge story. Interested readers may want to consult James Neal Primm, *Lion of the*

Valley: St. Louis, Missouri, 1764–1980, third edition (St. Louis, 1998); Carl W. Condit, "Iron Truss Bridge Failures," Sara Ruth Watson, "The Rate of Bridge Failure," and Howard S. Miller, "Truss Failures Reconsidered," *Technology and Culture* 22 (October 1981): 846-850; John A. Kouwenhoven, "The Designing of Eads Bridge," *Technology and Culture* 32 (October 1982): 535-68; Arthur W. Hebrank, *The Geologic Story of the St. Louis Riverfront* (Rolla, Mo., 1989); Timothy R. Mahoney, *River Towns in the Great West* (Cambridge, 1990); Sverdrup-MetroLink Project Management Group, *Historic American Engineering Record MO-12: Eads Bridge* (St. Louis, 1991); William Cronon, *Nature's Metropolis: Chicago and the Great West* (New York, 1991); Andrew Hurley, "On the Waterfront: Railroads and Real Estate in Antebellum St. Louis," *Gateway Heritage* 13, no. 4 (Spring 1993): 4-17; Katharine T. Corbett and Howard S. Miller, *Saint Louis in the Gilded Age* (St. Louis, 1993); Henry Petroski, *Engineers of Dreams: Great Bridge Builders and the Spanning of America* (New York, 1995); and especially Robert W. Jackson, "James Eads, The St. Louis Bridge, and the Complexities of Capitalism" (Ph.D. dissertation, University of Texas at Austin, 1997), by far the best effort yet to set Eads and his bridge in the broader context of Gilded Age business enterprise.

As Eads Bridge enters its next historical phase, we would like to thank its creator for his enduring masterpiece and our readers for their continued interest. Lee Sandweiss, Director of Publications at the Missouri Historical Society, and Beverly Jarrett, Director of the University of Missouri Press, deserve credit for this new edition, yet more evidence of their commitment to this region's remarkable history and culture.

<div style="text-align: right;">

HOWARD S. MILLER,
Morro Bay, California

QUINTA SCOTT,
St. Louis, Missouri

December 1998

</div>

Acknowledgments

Our study of Eads Bridge would have been impossible without the help of many individuals and institutions. Beryl Manne, Eric Newman, Joseph Vollmar, Jr., Edward L. Rheinhardt, and Dr. John Roberts generously shared their knowledge of James Eads and his bridge. Gail Guidry, Marvin Kreisman, Therese Dawson, Martha Hilligoss, Mary Mewes, Elizabeth Kirchner, and Robert Vogel located and made available historical photographs and graphics. Clay Purcell offered technical advice on shooting the contemporary photographs. Beverly Bishop, Vivian Eveloff, Leslie J. Laskey, and Robert LaRouche advised us on editing the photographs; while James Neal Primm and David Hatcher suggested improvements to the text. Russell C. Solomon answered important technical questions regarding the metallurgy of chrome steel. The Mercantile Library Association, the St. Louis Public Library, the Missouri Historical Society, the American Photography Museum, the University of Missouri–St. Louis, Washington University, the National Museum of Transport, the Smithsonian Institution, the Library of Congress, and the Franklin Institute of Philadelphia all permitted us to use materials from their collections. The Terminal Railroad Association gave us access to the bridge itself and allowed us to reproduce a hitherto unpublished Eads Bridge engineering drawing. A grant from the Charles Ulrick and Josephine Bay Foundation made it possible to reproduce the graphics and photographs with proper brilliance and clarity.

Most of all we are grateful to Louis Gerteis, who first suggested that we collaborate; to Edward King of the University of Missouri Press, who helped turn the idea into a book; and to Marlo, Barrie, Kalon, Eric, Kurt, and Andrew, who put up with us.

HOWARD S. MILLER
QUINTA SCOTT
St. Louis, Missouri

September 1978

The Eads Bridge
Photographs by Quinta Scott

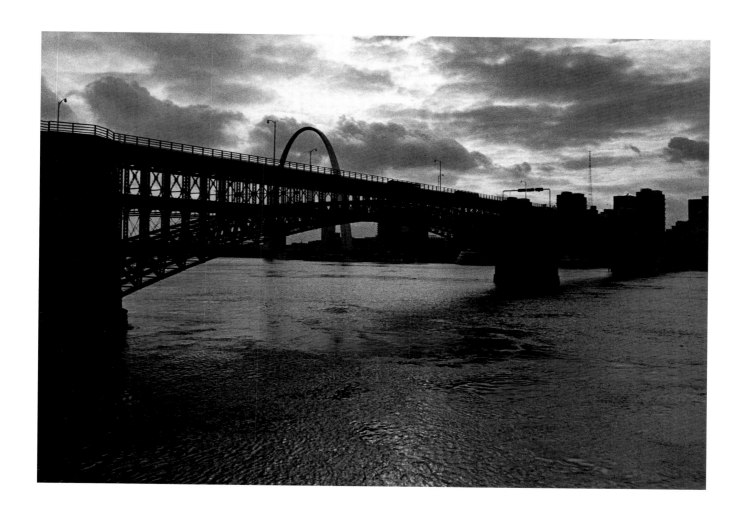

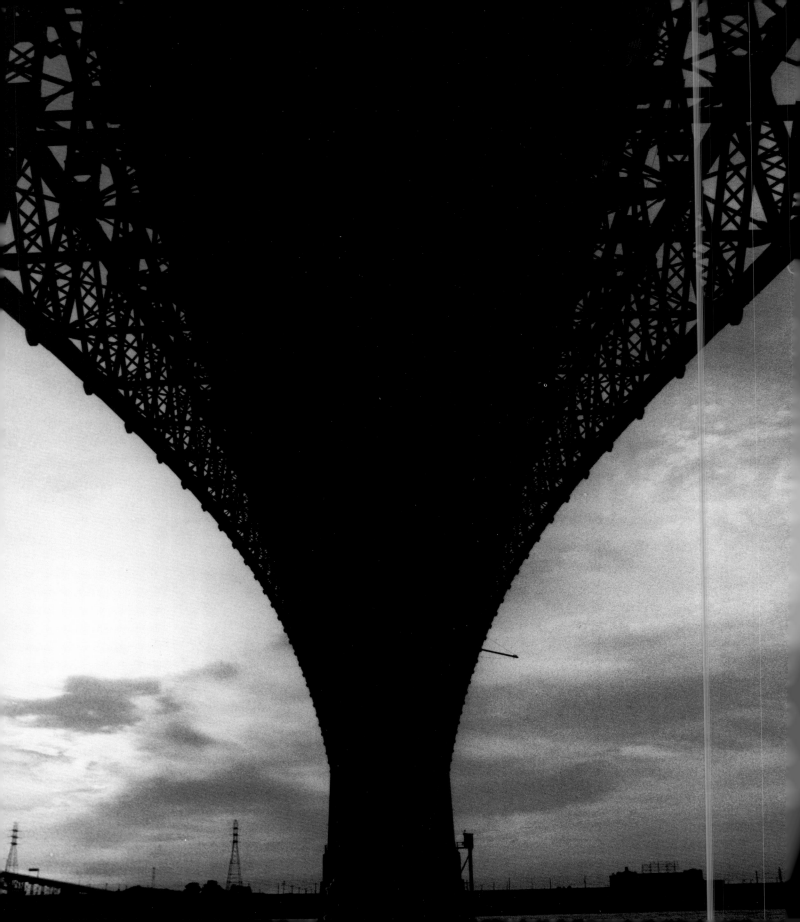

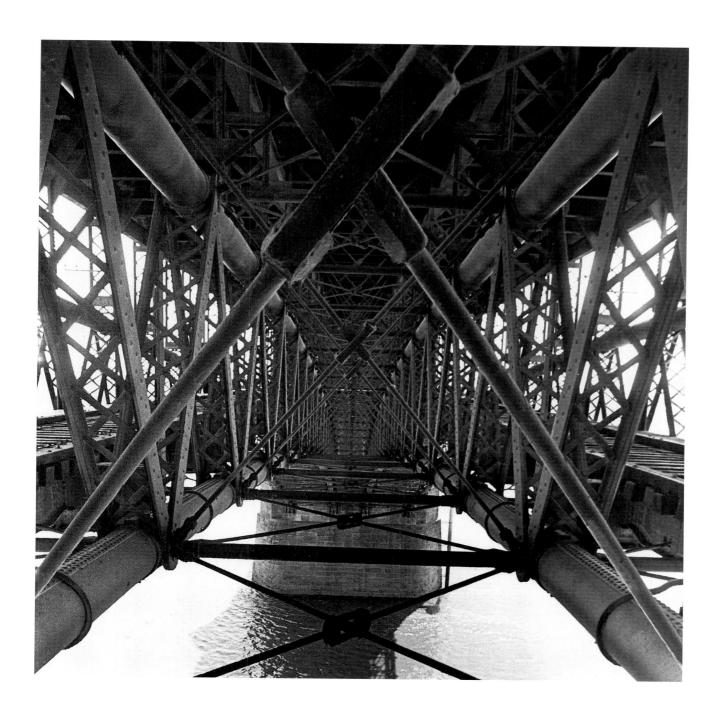

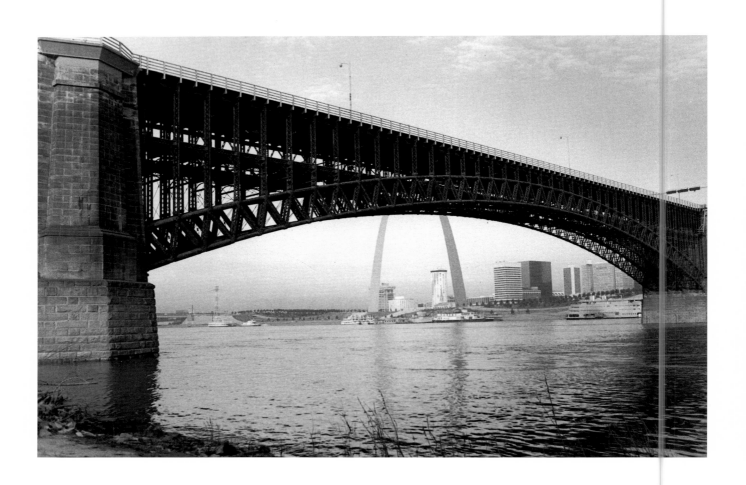

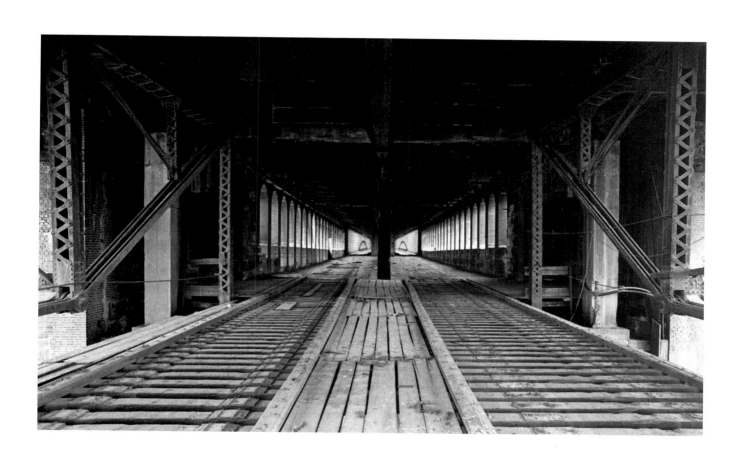

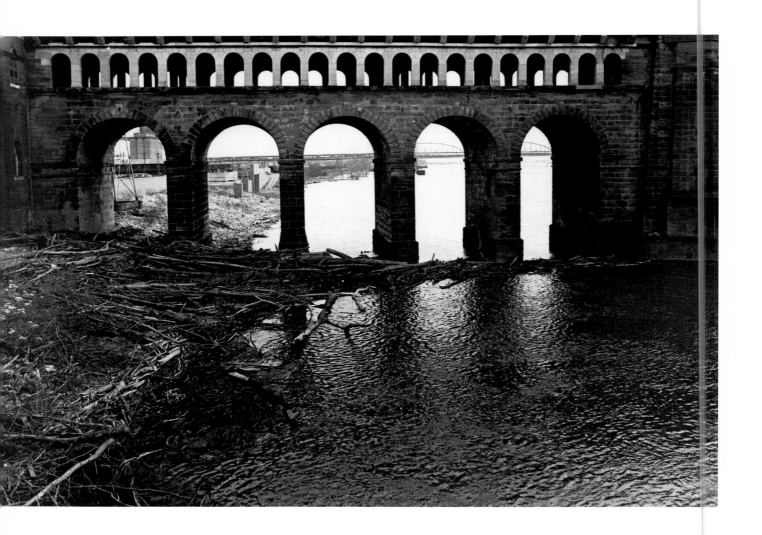

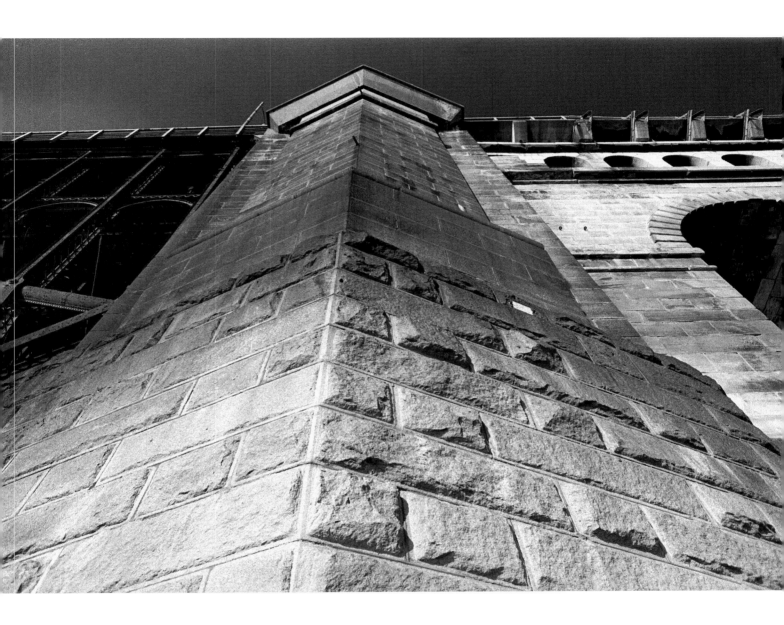

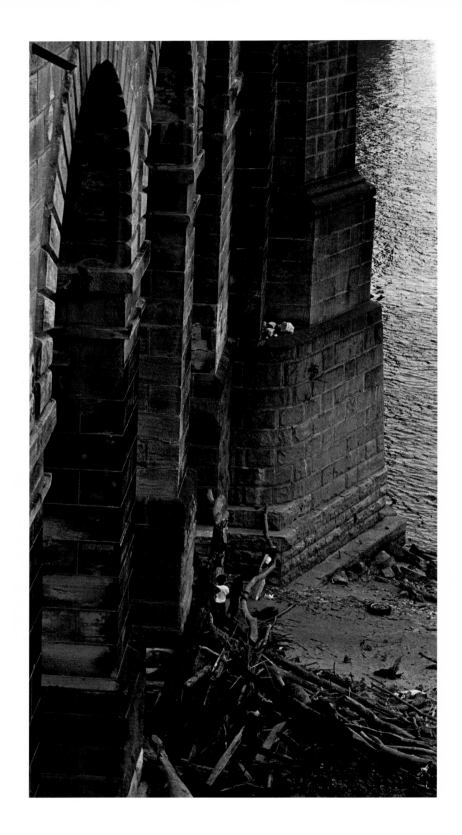

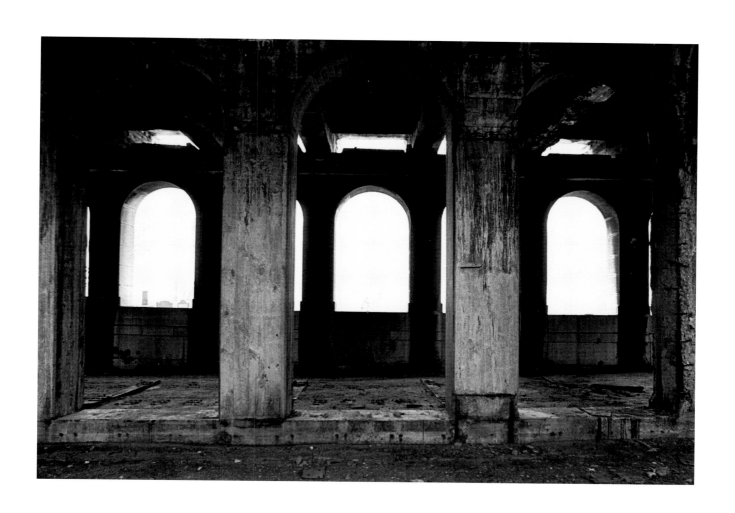

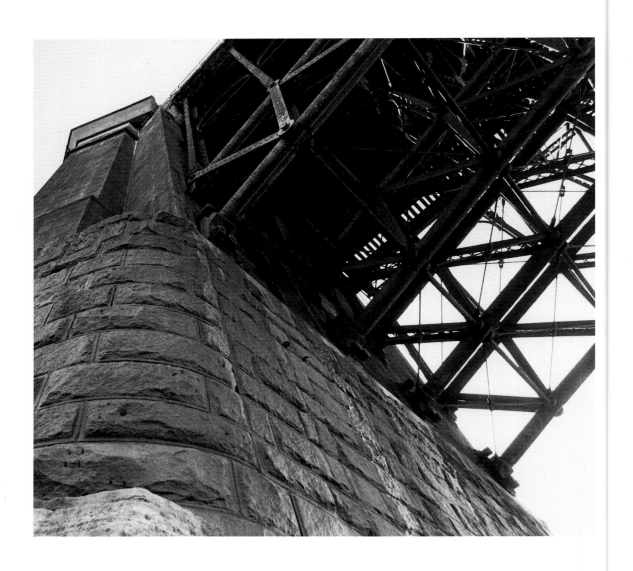

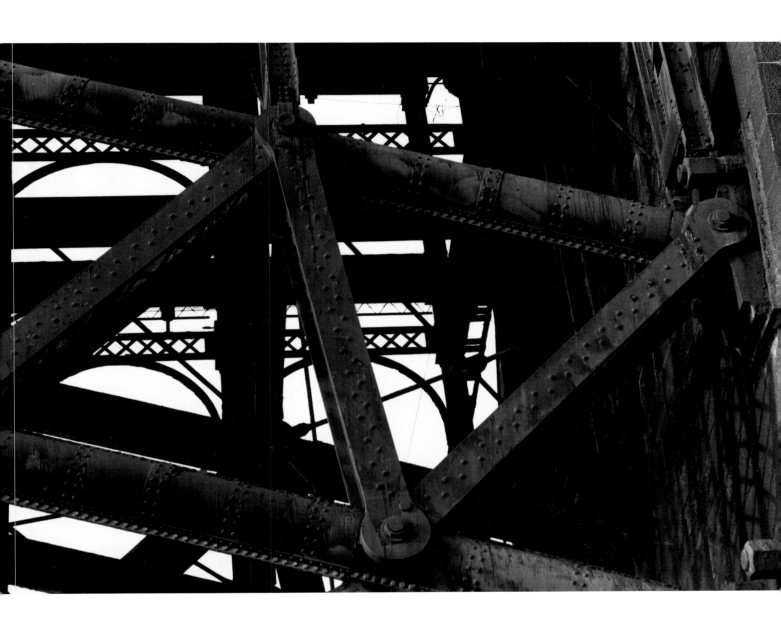

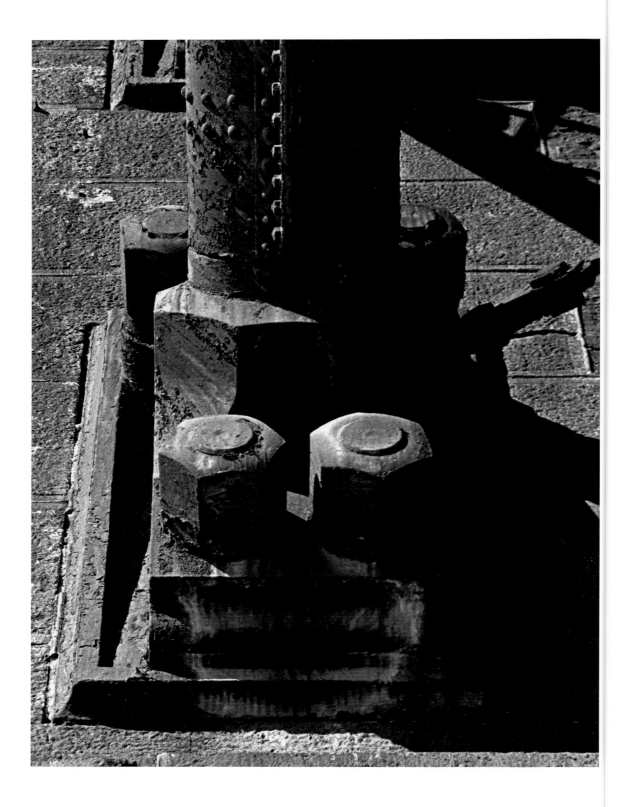

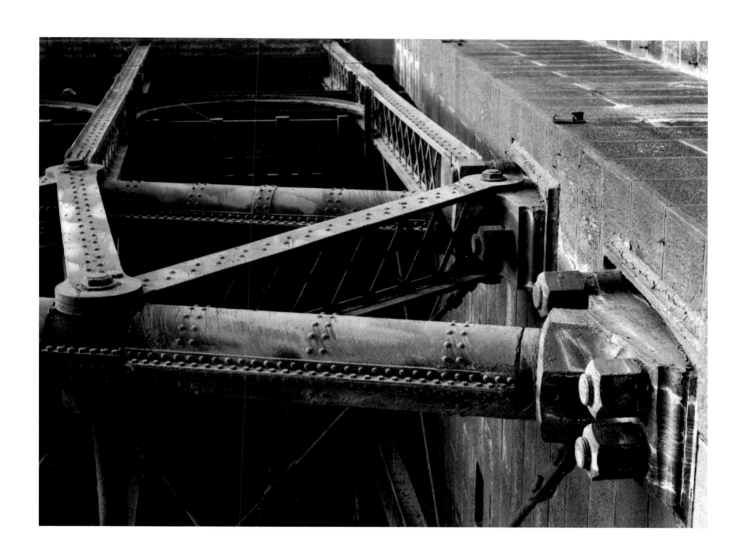

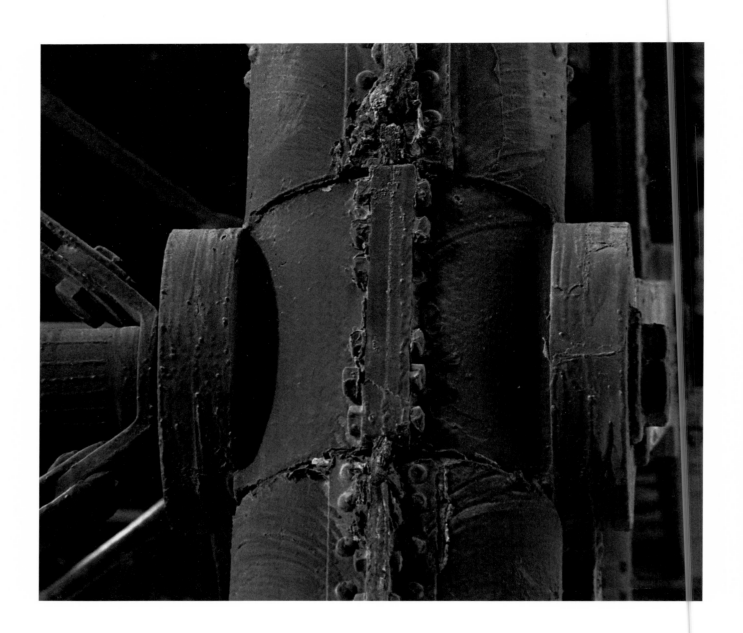

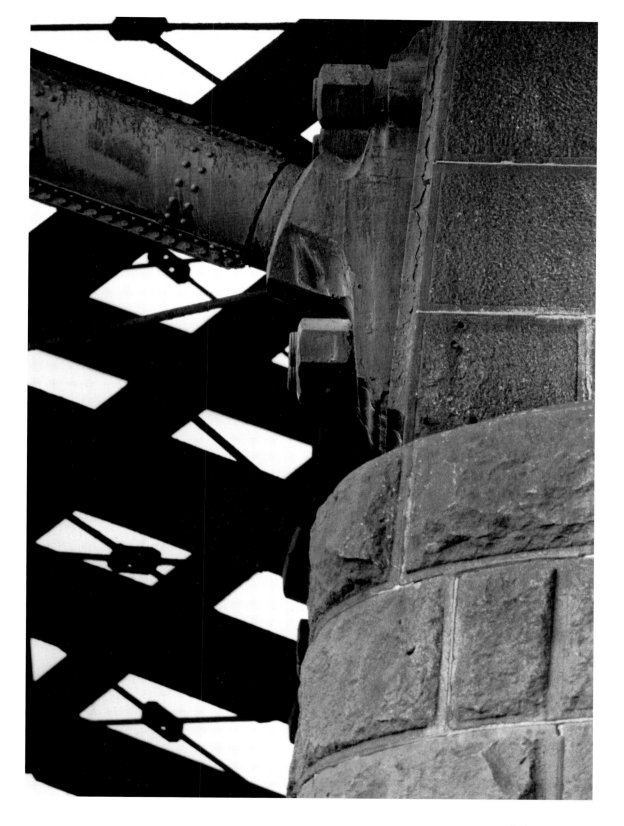

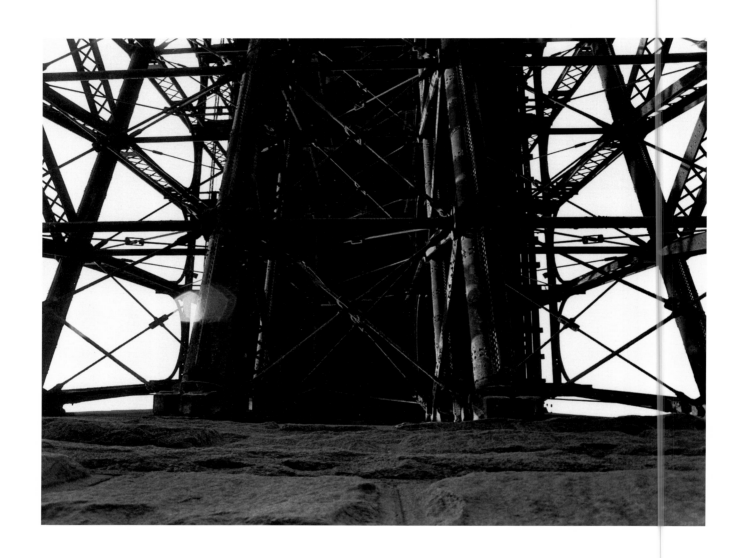

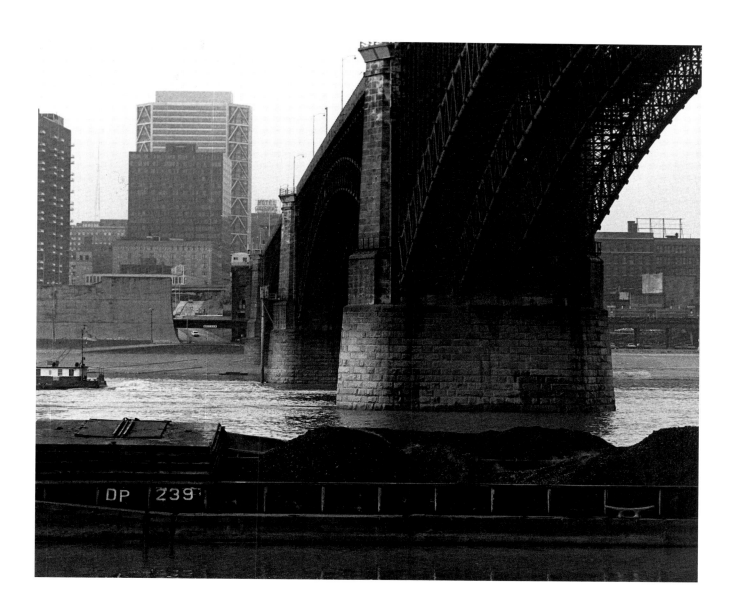

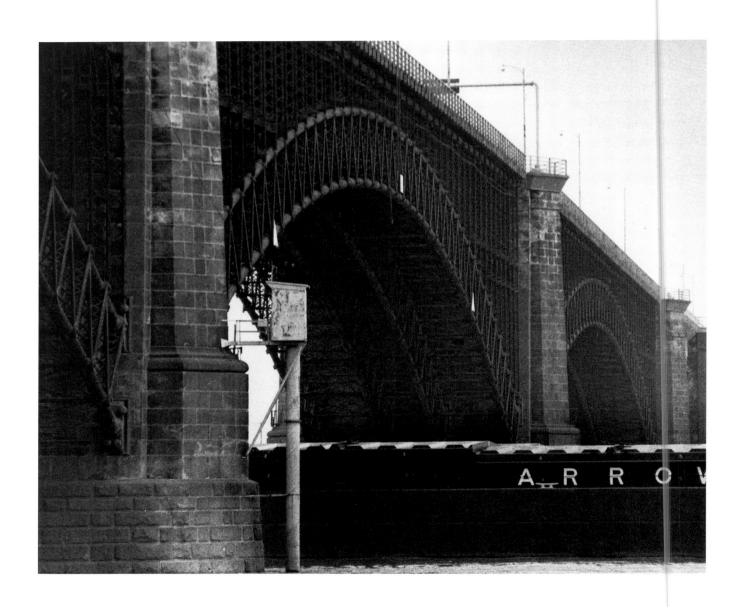

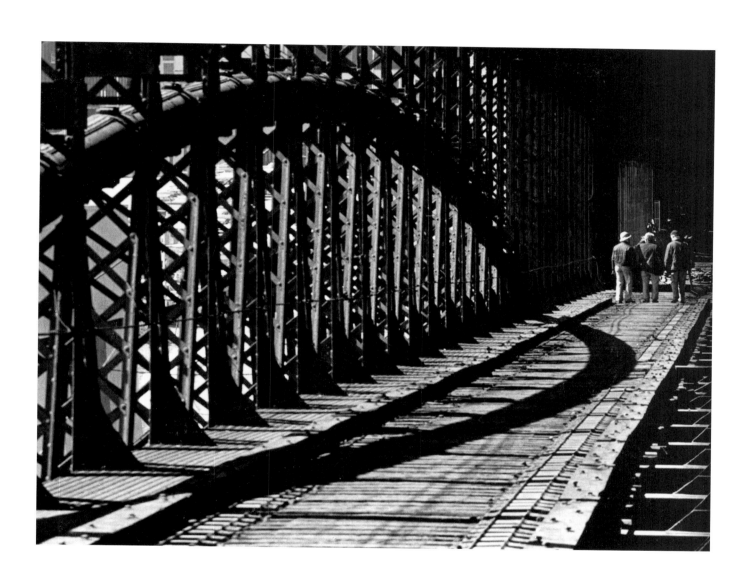

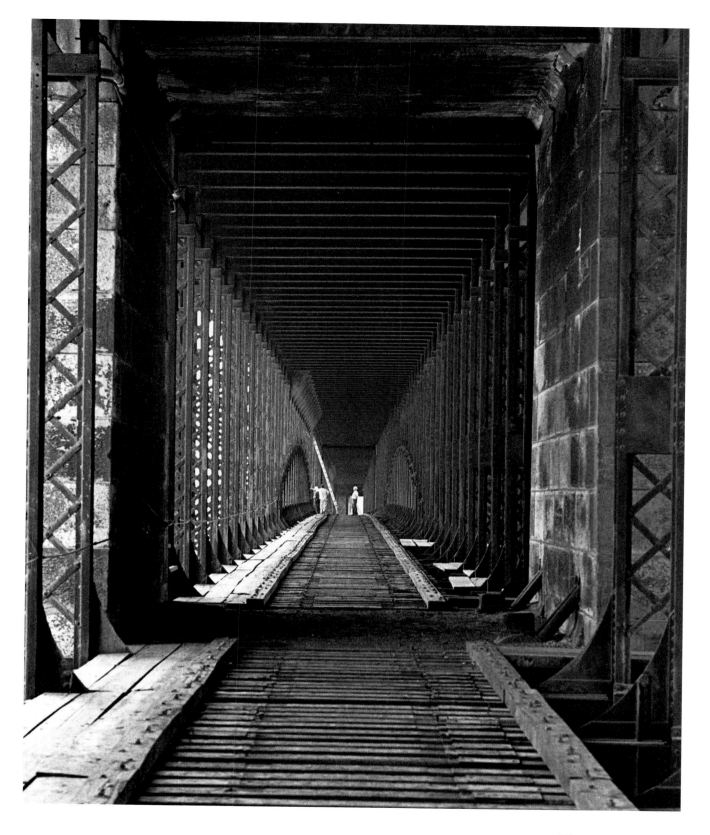

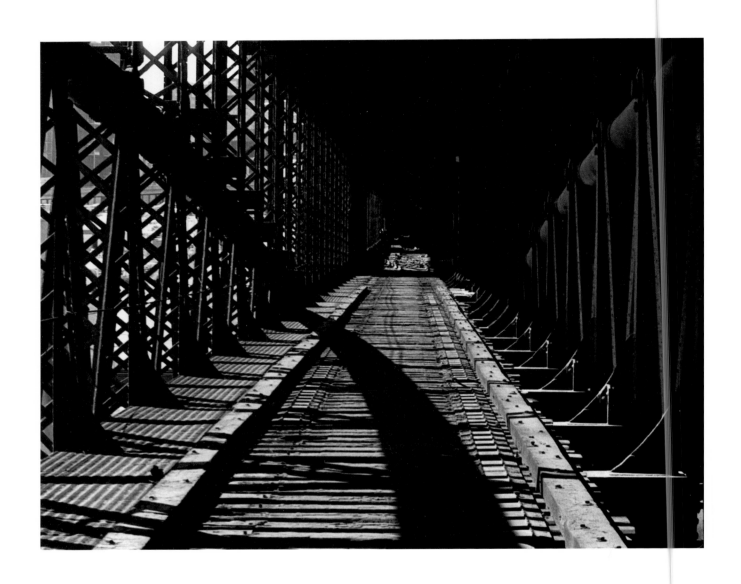

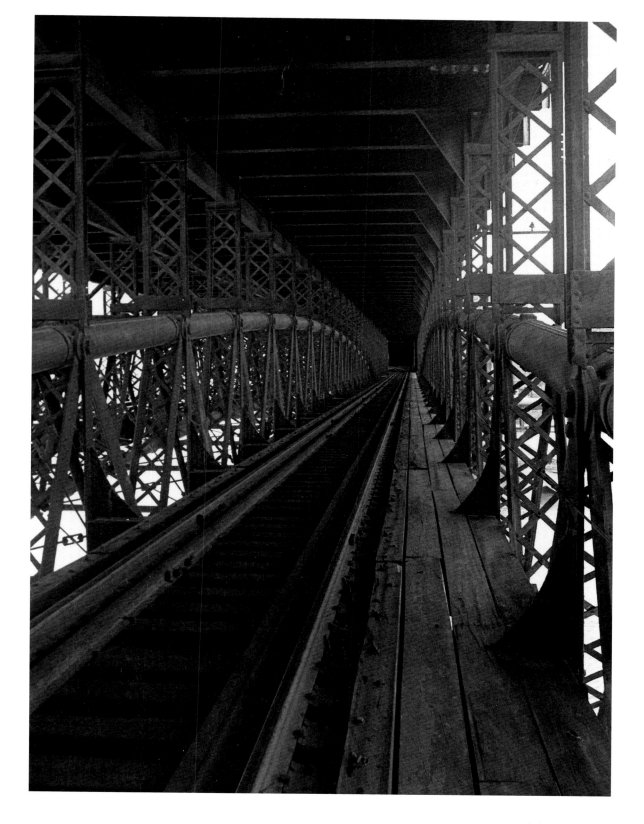

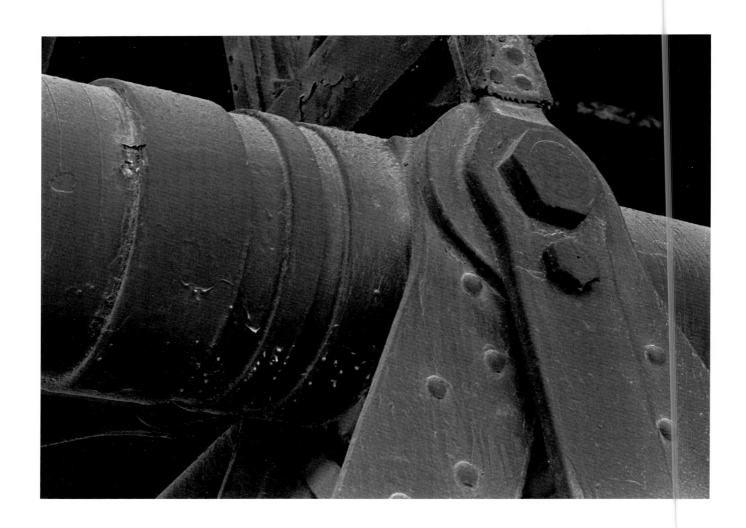

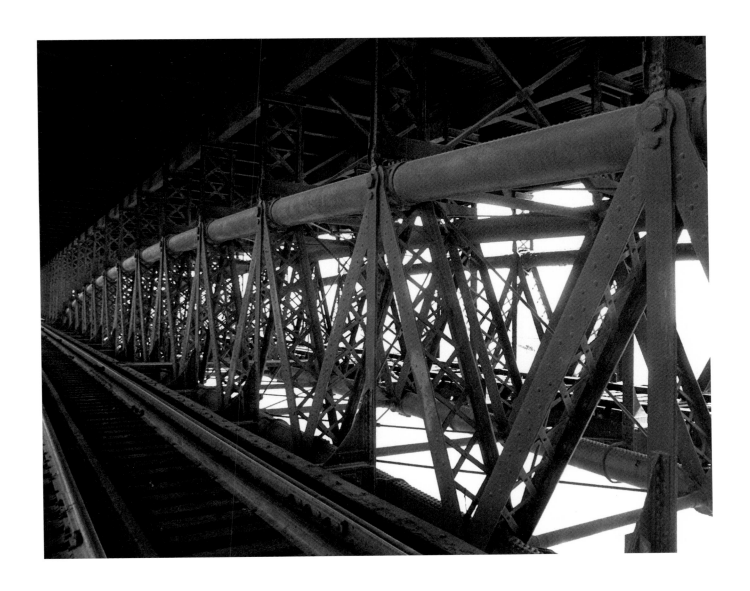

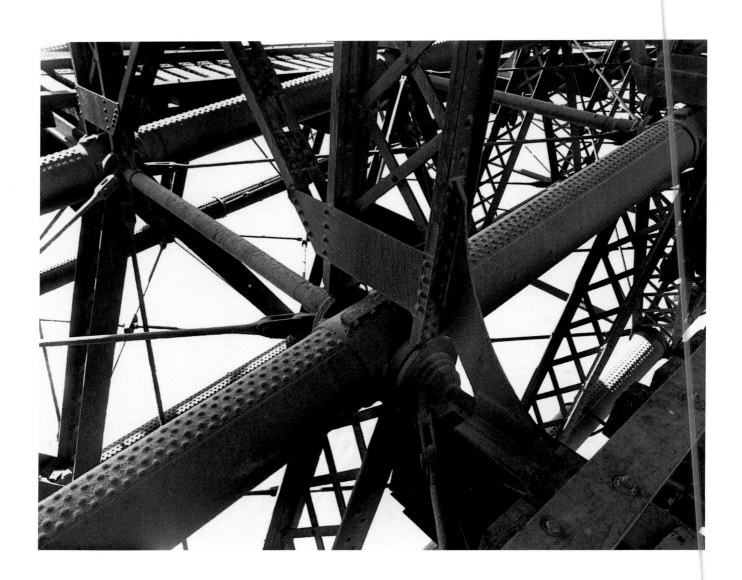

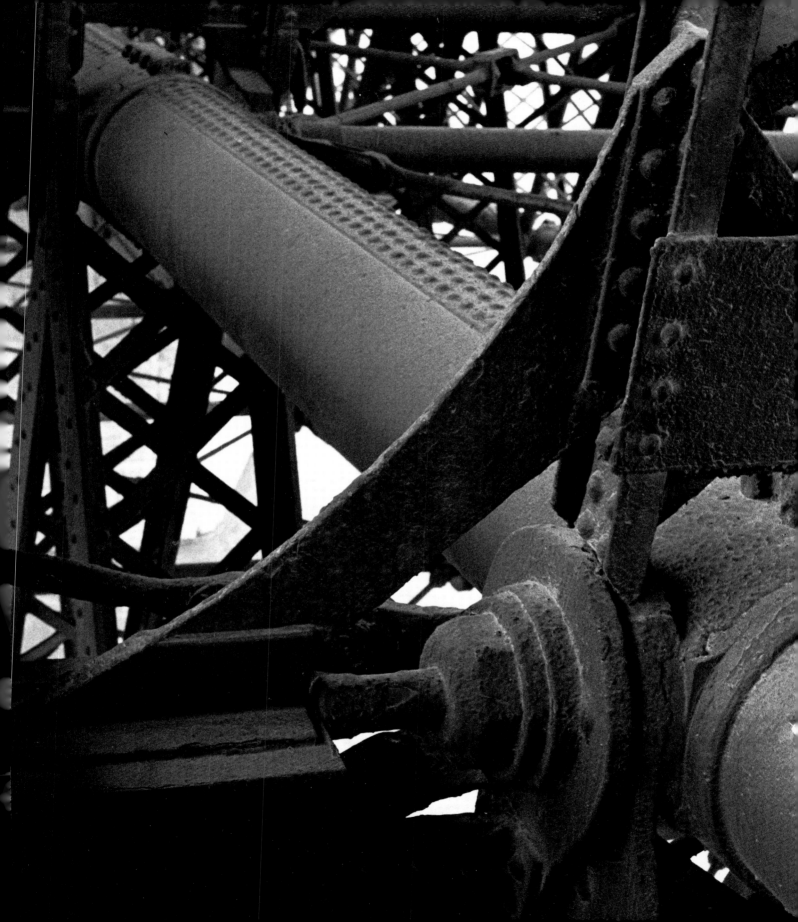

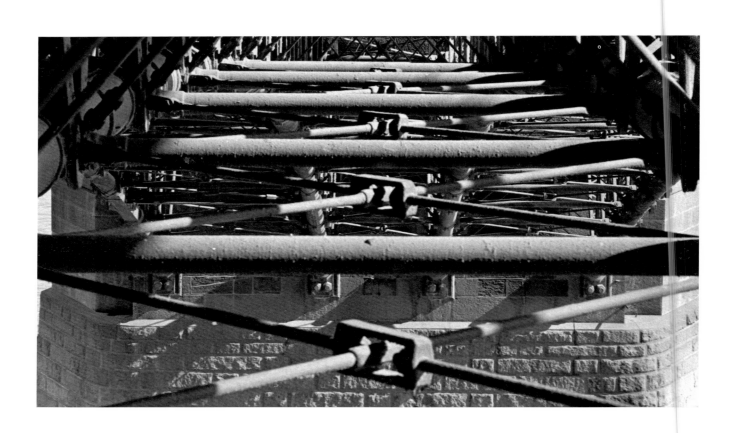

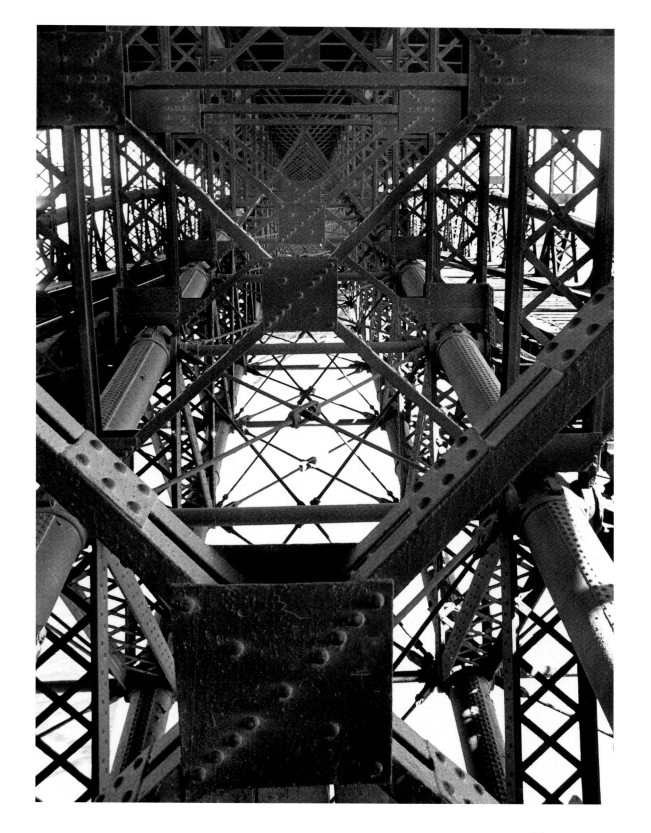

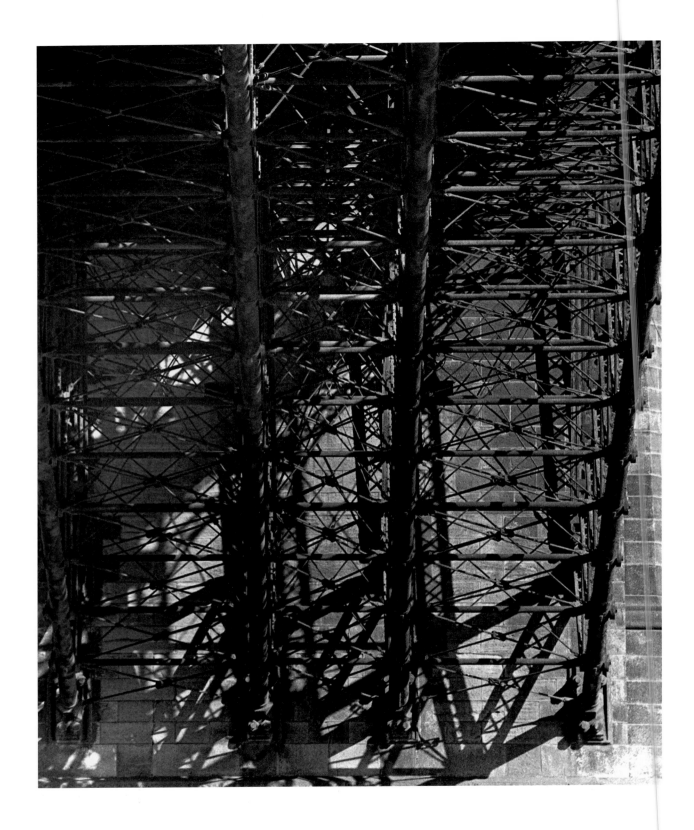

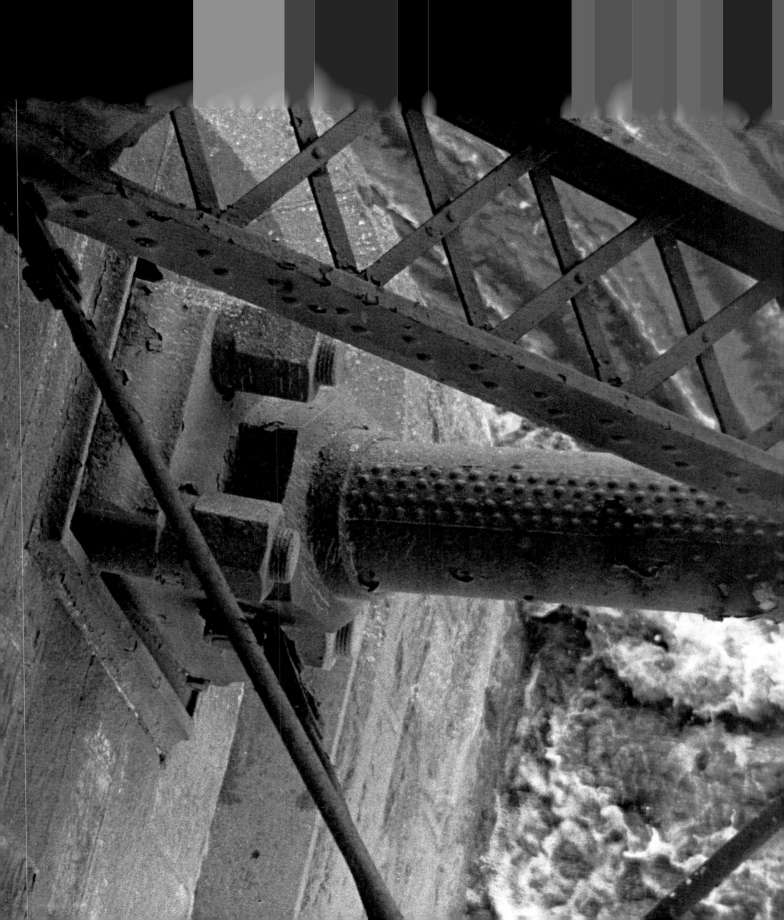

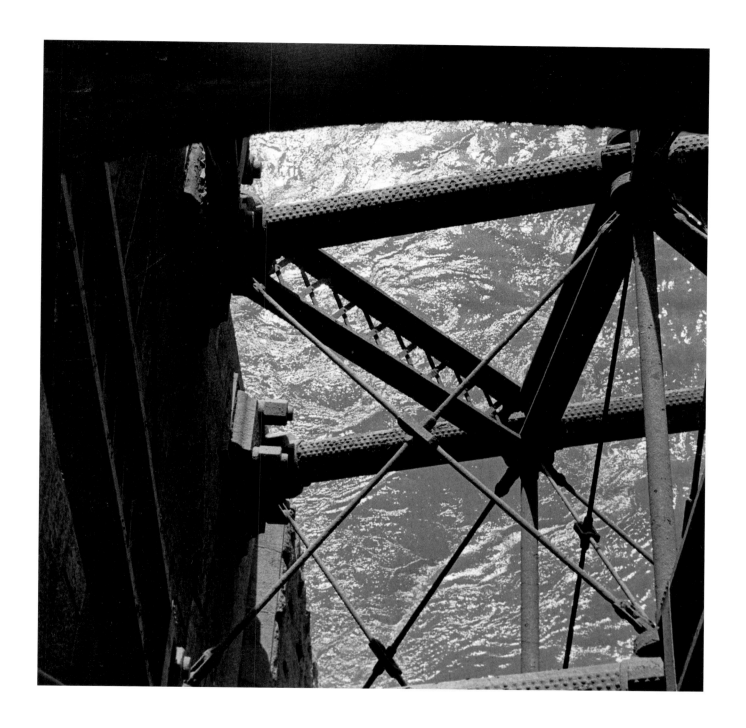

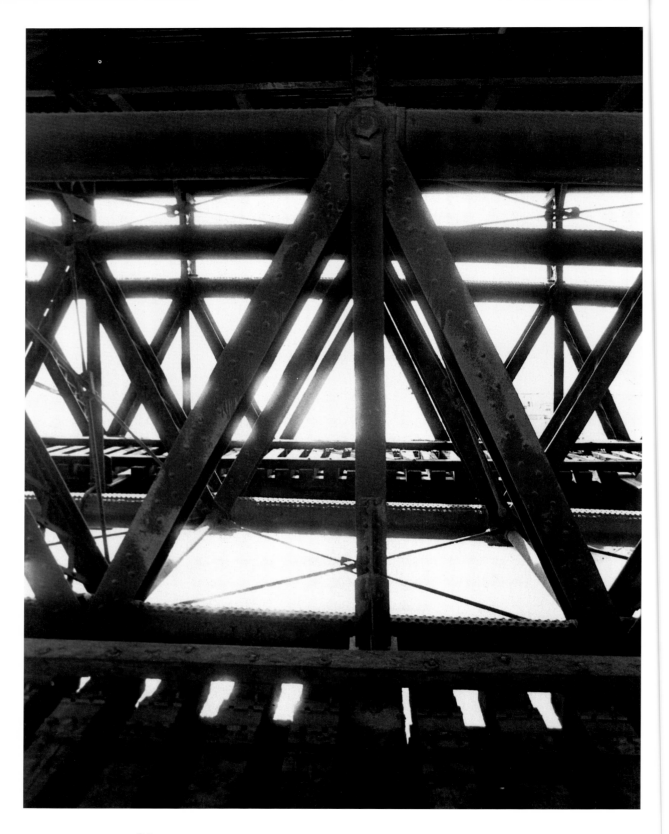

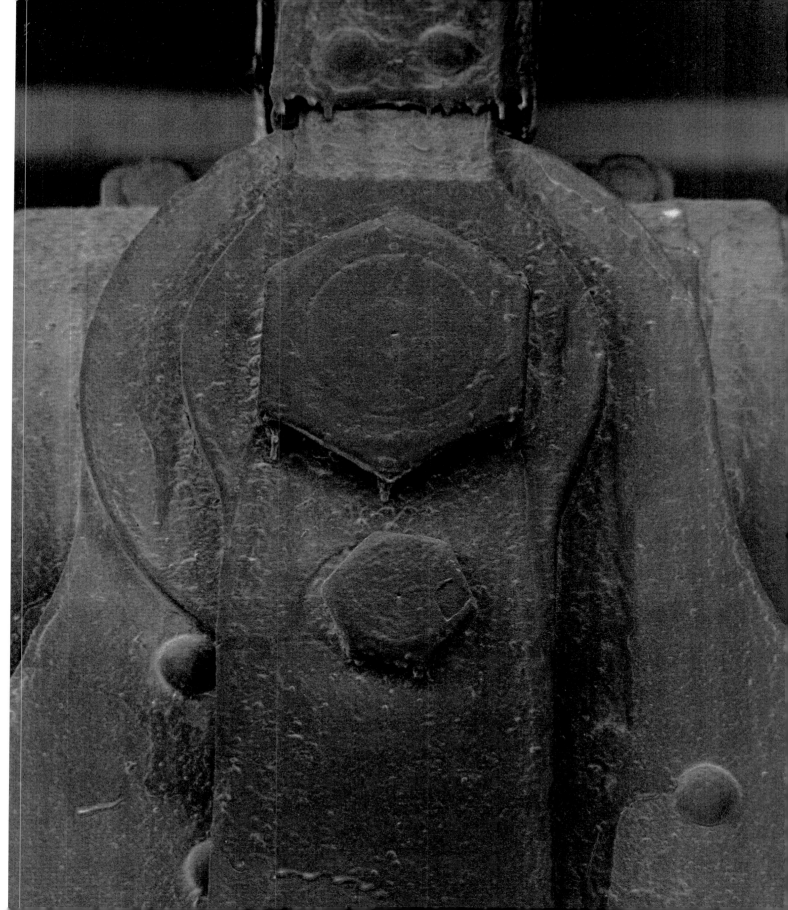

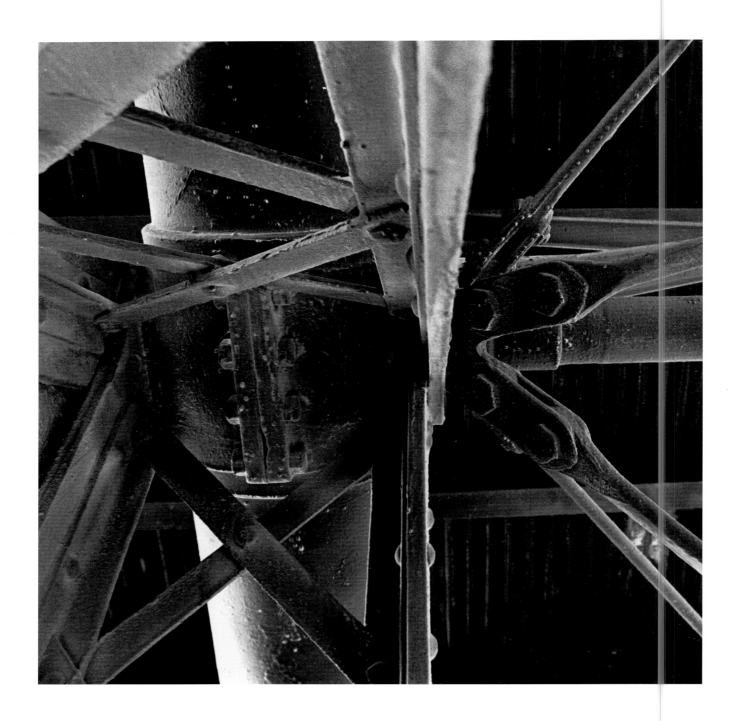

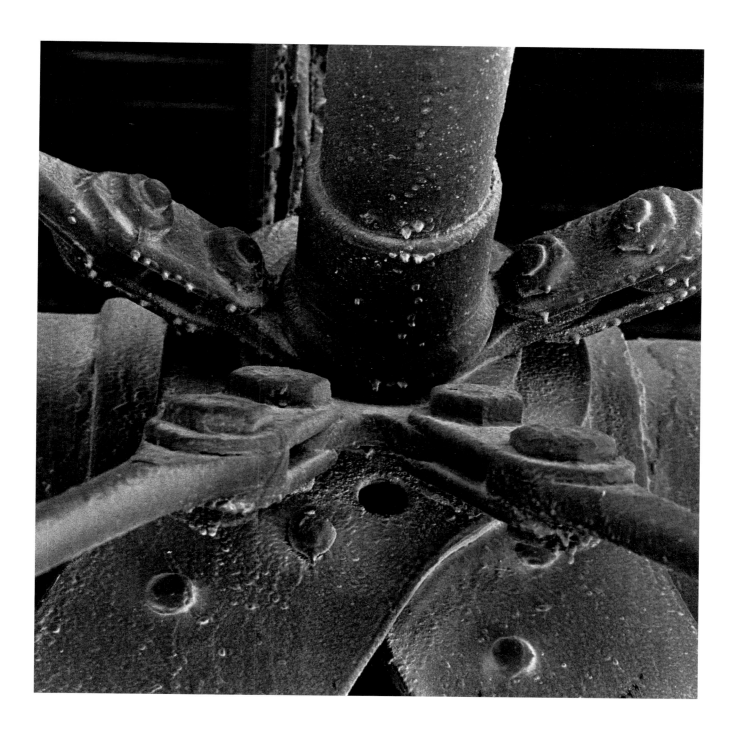

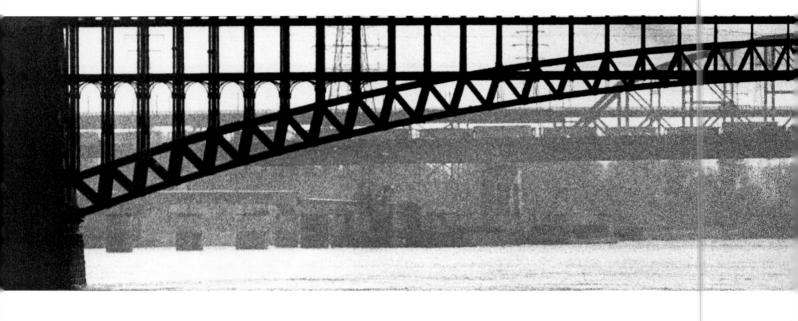

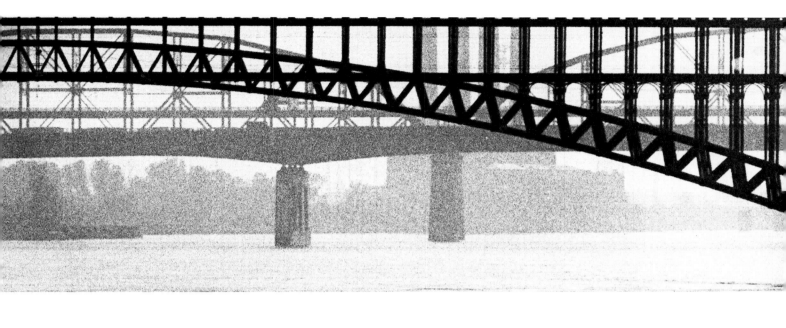

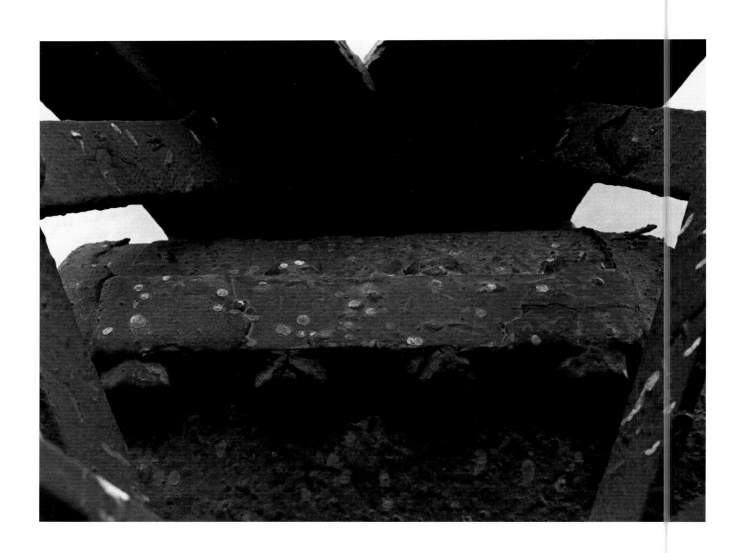

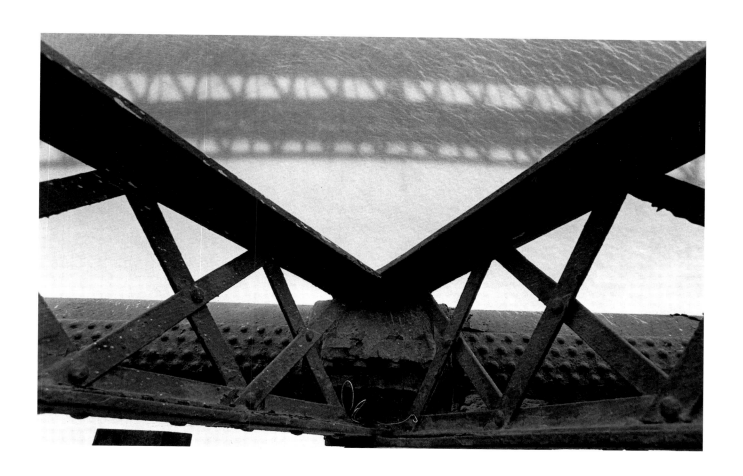

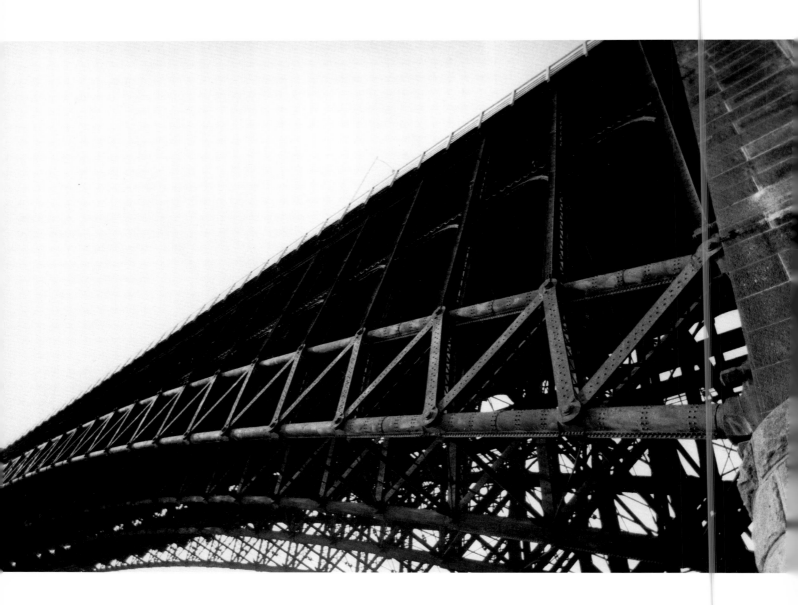

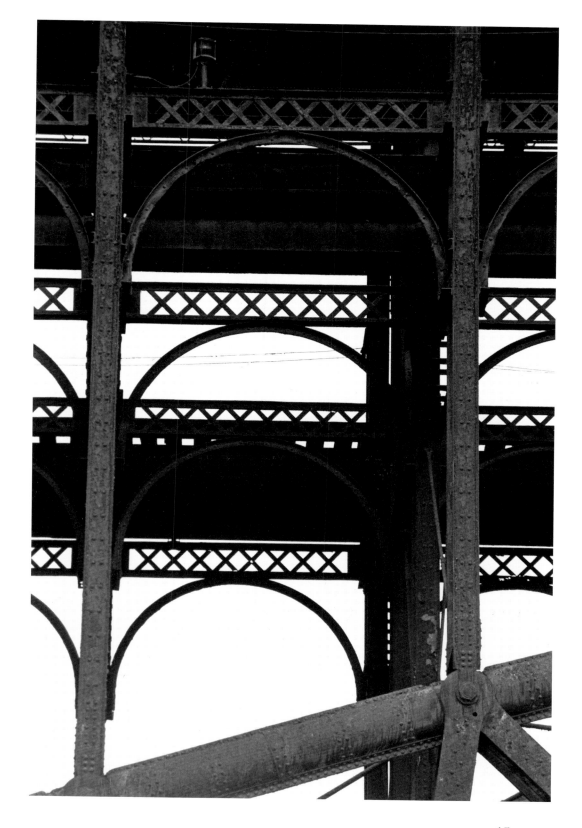

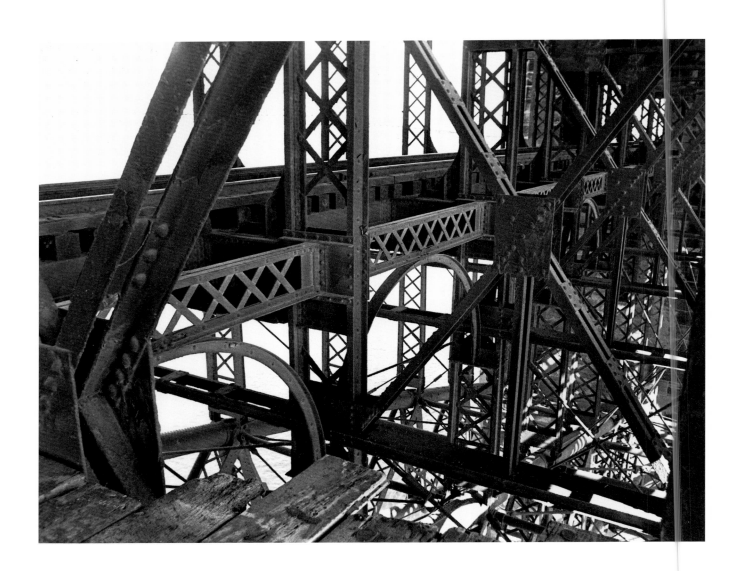

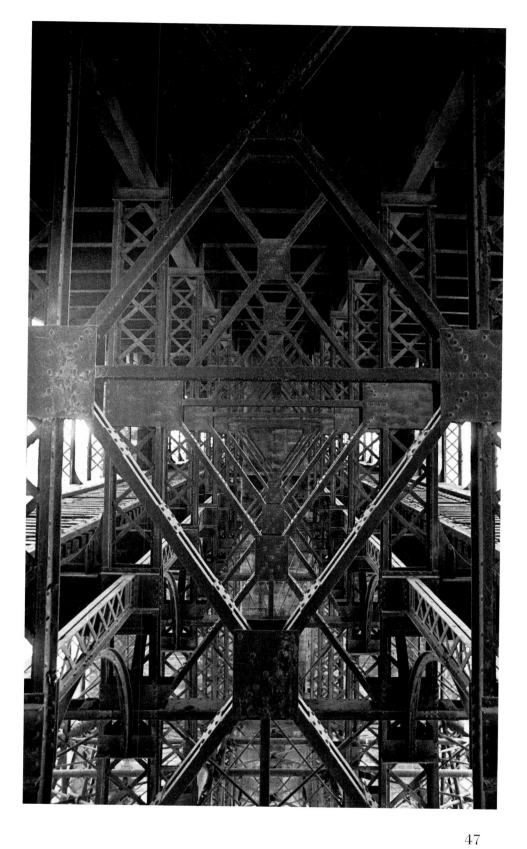

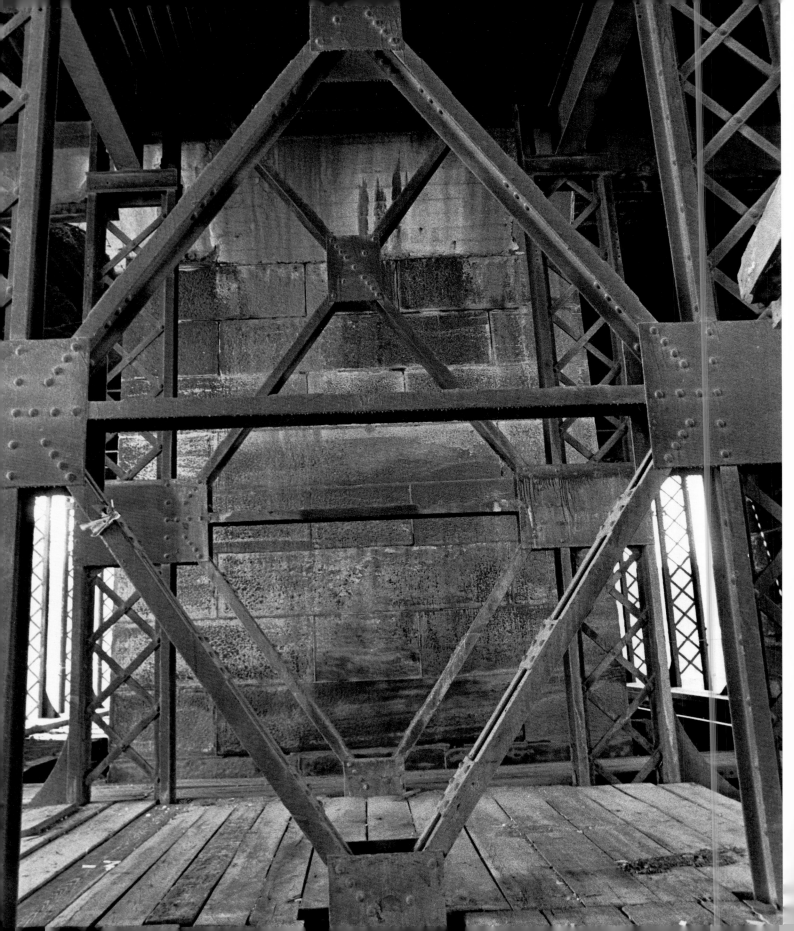

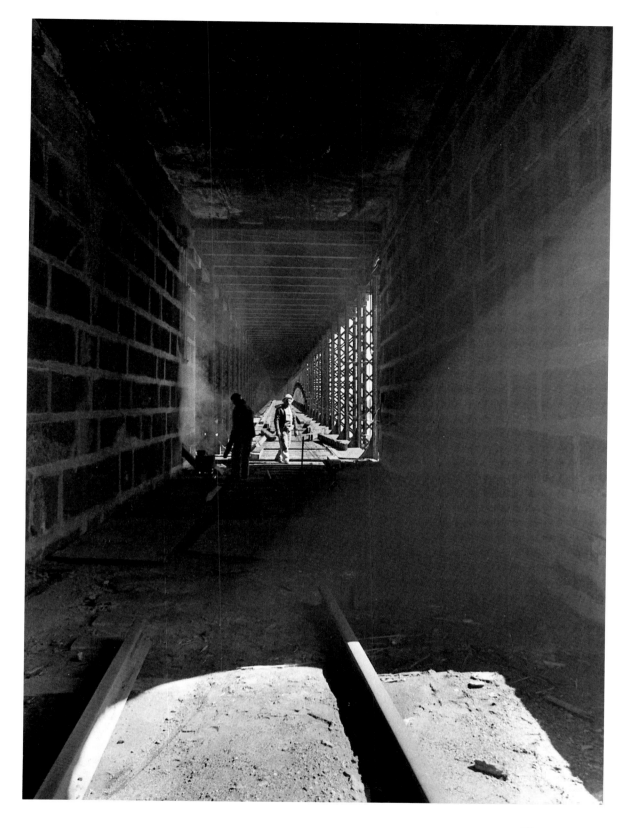

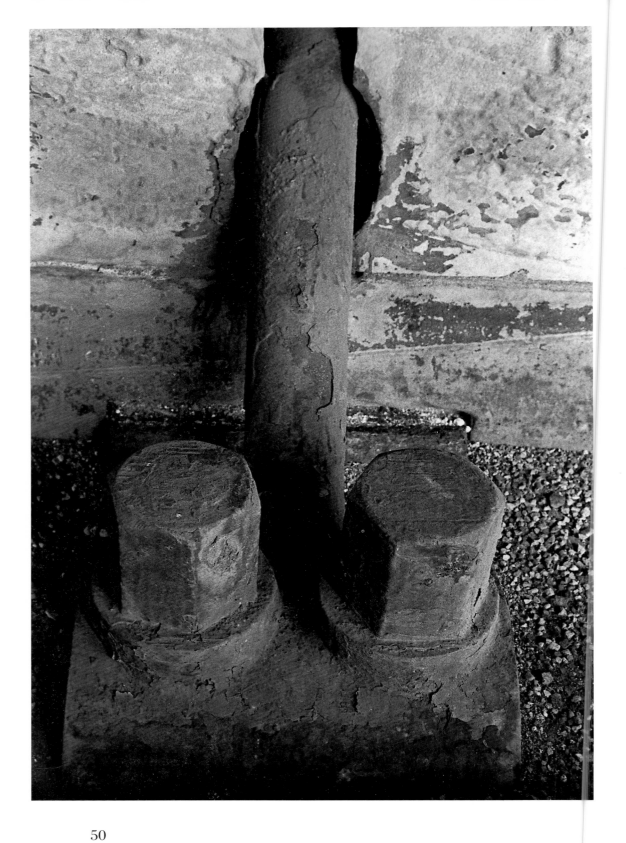

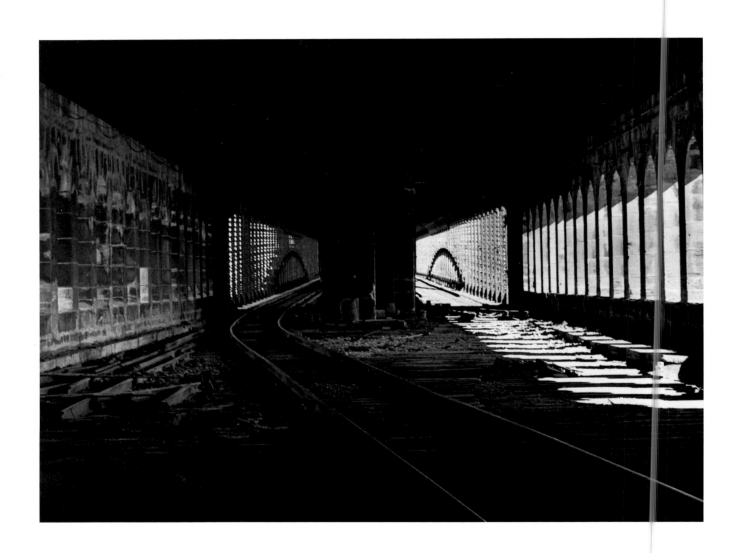

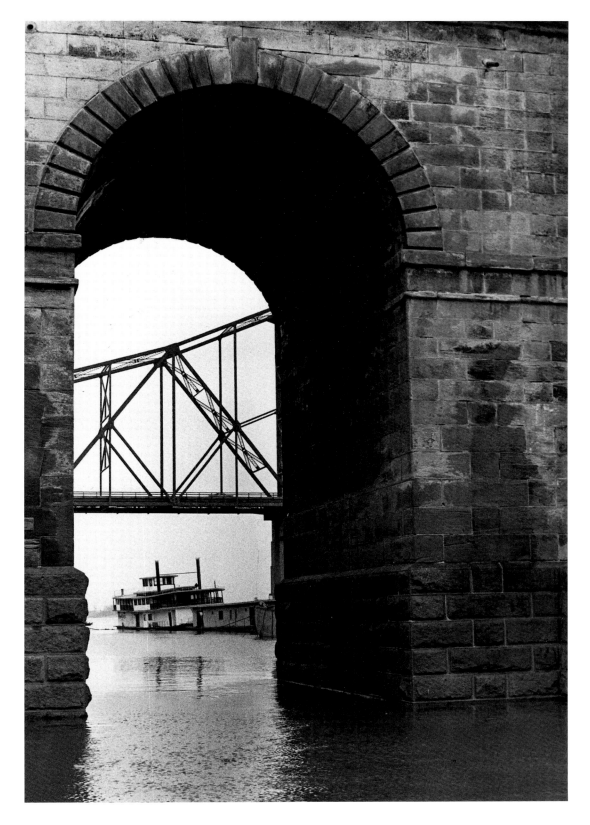

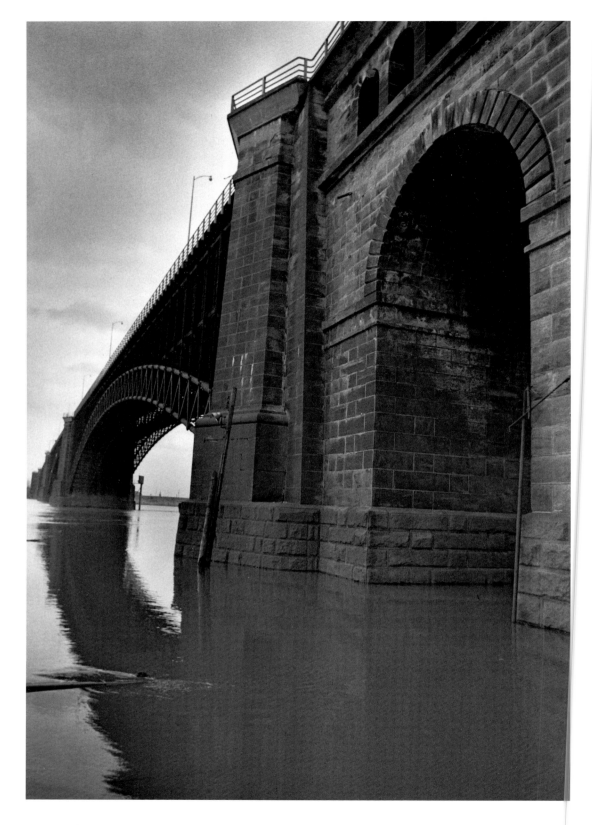

America's leading bridge contractor, Jacob Linville, was sure Eads Bridge would never work. After reviewing the preliminary plans in 1867 he concluded that the form was suspect, the material untried, the method risky at best. The bridge might not even support its own weight, much less heavily laden freight trains, wagons, and trolleys. "I cannot consent to imperil my reputation by appearing to encourage or approve of its adoption," wrote Linville. "I deem it entirely unsafe and impracticable, as well as in fault of the qualities of durability."[1]

Despite Linville's initial reservations, his firm eventually built the St. Louis Bridge according to James Eads's novel design. A century and a quarter later the bridge still stands solidly in place, its massive piers and graceful arches fitting monuments to James Eads's entrepreneurial imagination, technical daring, artistic vision, and stubborn insistence on having his own way.

It was typical of Eads that he had never before built a bridge. His career had been a succession of bold innovations marked by technical daring and founded on a unique and intimate knowledge of the Mississippi River. Years later, Andrew Carnegie, Jacob Linville's partner in the Keystone Bridge Company, recalled that Eads had been a maverick, "an original genius *minus* scientific knowledge to guide his erratic ideas of things mechanical."[2] Carnegie was usually a shrewd judge of men, but he utterly misread James Eads. Eads was self-taught in an age when engineering was fast becoming professionalized. He did display the kind of Yankee ingenuity celebrated by mechanics who cared more for "know-how" than "know-why"; but he also had a strong theoretical bent, an interest in higher math-

1. Jacob Linville to the Directors of the Illinois and St. Louis Bridge Co., July 1867, in Calvin M. Woodward, *A History of the St. Louis Bridge* (St. Louis, 1881), pp. 15–16. All subsequent accounts of the bridge have drawn heavily on Woodward's magistral volume for both facts and interpretations. For a sampling of the literature, see Joseph Gies, *Bridges and Men* (Garden City, N.Y., 1963); Carl Condit, *American Building* (Chicago, 1968); *The Eads Bridge, An Exhibition Prepared by the Art Museum and the Department of Civil Engineering, Princeton University* (Princeton, 1974); Joseph E. Vollmar, Jr., *James B. Eads and the Great St. Louis Bridge* (St. Louis, 1974); David B. Steinman and Sara R. Watson, *Bridges and Their Builders* (New York, 1941); John A. Kouwenhoven, "Eads Bridge: The Celebration," *Bulletin of the Missouri Historical Society* 30 (April 1974):159–80; John A. Kouwenhoven, "Downtown St. Louis as James B. Eads Knew it When the Bridge was Opened a Century Ago," *Bulletin of the Missouri Historical Society* 30 (April 1974): 181–95.

2. Andrew Carnegie, *The Autobiography of Andrew Carnegie* (Boston, 1920), p. 114.

ematics, and an abiding faith that the Creator had fashioned a rational, intelligible world in which matter and motion behaved according to universal laws. "The laws which guide an engineer are immutable, and never deceive," he wrote. "Failures and disasters... result almost invariably from the non-observance of these laws, or from a want of knowledge of them." Critics often found his cool self-assurance overbearing, and he sometimes showed an impatience with human imperfection that came from being right too much of the time. But to call Eads arrogant is to miss the special quality of nineteenth-century science and technology. He was supremely confident because he lived the conviction that Nature was not only knowable but known and that technical knowledge and human will could master the universe. Truth was absolute, engineering an exact science.[3]

Throughout James Eads's childhood, a succession of marginally profitable business ventures had kept his family on the move, drifting from river town to river town, success always beckoning westward. He had been born on 23 May 1820 in Lawrenceburg, Indiana, and christened James Buchanan Eads in honor of his second cousin, an upward-bound Pennsylvania politician who would become the fifteenth president of the United States. In September 1833 the Eads family journeyed to St. Louis, where they planned to open a general store. Tragically, on the morning of their arrival their steamboat—and with it all their possessions—burned to the waterline.

Thirteen-year-old James went to work to help the family recover its losses. For five years he clerked at Williams and Duhring's dry-goods store. In his spare time, he tinkered with model steamboats and a variety of mechanical inventions. Fortunately, one of his employers, Barrett Williams, shared Eads's enthusiasm for science and technology and fostered it by opening his personal library to the young mechanic. It was there, after hours, that Eads began his education as an engineer.[4]

3. Estill McHenry, comp., *Addresses and Papers of James B. Eads, Together with a Biographical Sketch* (St. Louis, 1884), p. 154. McHenry's edition is the most accessible source for Eads's many fugitive writings. Unfortunately, the editor omitted numerous illustrations and most of the technical appendixes that appeared in the original publications.
4. There is no authoritative biography of James Eads. Save for a modest collection in the Missouri Historical Society, St. Louis, Mo., the bulk of Eads's papers are

If mechanics was his first passion, the river became his second. Just a few blocks from the dry-goods store lay the Mississippi, its long wharves teeming with commerce, a hundred steamboats filling the air with the sounds of progress and the promise of adventure. Eads could no more resist than could his upriver contemporary Mark Twain. "When I was a boy," wrote Twain in *Life on the Mississippi*, "there was but one permanent ambition among my comrades in our village on the west bank of the Mississippi River. That was, to be a steamboatman. We had transient ambitions of other sorts, but they were only transient.... The ambition to be a steamboatman always remained."[5]

Mark Twain became a pilot, mastering the river by pitting practical observation and sheer memory against the mystery of the shifting current. Eads, too, would master the river; but he would augment river lore and personal experience with the science of hydraulics. He began modestly as a purser (*mud clerk*, in river lingo) on a steamer engaged in the upper Mississippi lead trade. For three years he worked the inland waterways, pondering the river and continuing his informal studies in his spare time. Then, in 1842, he hit upon a scheme that would capitalize on his mechanical know-how, satisfy his curiosity about the river, and possibly make him rich. He would become a wrecker.

For all their majesty and romance, western steamboats were notoriously short-lived. If they managed to survive fire and the violent explosions of their high-pressure boilers (seventy-two explosions claimed more than six hundred lives in the 1830s alone), they were likely to founder on the countless snags that waited beneath the surface of the muddy river. Double-hulled snag boats, specially rigged with hoists and tackles, labored constantly to keep the main channels clear; but each high water undid their work by leaving behind a new deposit of driftwood and other debris.

scattered, and the standard biographies often substitute family anecdote for critical historical analysis. See Louis How, *James B. Eads* (Boston, 1900); Florence Dorsey, *Road to the Sea: The Story of James B. Eads and the Mississippi River* (New York, 1947); and Charles E. Snyder, "The Eads of Argyle," *Iowa Journal of History and Politics* 42 (January 1944):73–90.

5. Samuel Clemens [Mark Twain], *Life on the Mississippi* (New York, 1874), chapter 4. See also Emerson Gould, *Fifty Years on the Mississippi; or, Gould's History of River Navigation* (St. Louis, 1889), pp. 483–88. The best general account is Louis C. Hunter, *Steamboats on the Western Rivers, an Economic and Technological History* (Cambridge, Mass., 1949).

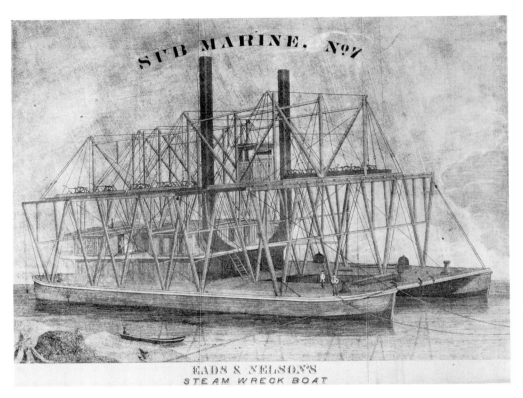

Eads's and Nelson's Submarine No. 7, 1858. Artist unknown.

Everywhere the western rivers were strewn with ruined hulls and sunken cargo. Much of the cargo was valuable, if only one could locate it in the muck and raise it to the surface.[6]

Plans in hand, in 1842 the twenty-two-year-old mud clerk approached two St. Louis boat builders, Calvin Chase and William Nelson, and offered them a partnership in a salvage venture if they would build him the peculiar craft he had designed. Eads's "submarine" was essentially a modified snag boat equipped with heavy hoisting gear, water- and sand-pumps, and a diving bell. Surprisingly, Chase and Nelson were convinced and joined the young entrepreneur in the enterprise.

Various types of diving bells had been in use on the western rivers for years. Eads's first model was a modified forty-gallon whiskey keg with one end knocked out. He attached lead weights to the open end, a cable and an

6. Hunter, *Steamboats on the Western Rivers*, pp. 181–304.

air hose to the closed end. Suspended upside down and supplied with air from pumps on deck, the bell could be lowered over a wreck or moved about near the riverbed itself. With his head in the air chamber and his feet on the bottom, a diver could grope along, exploring wrecks for sunken treasure.

It was hazardous work. Most professional divers were terrified of the murky, turbulent currents, so Eads did much of the underwater work himself. He later estimated that he had made more than five hundred trips to the bottom. There was scarcely a fifty-mile stretch of the Mississippi between St. Louis and New Orleans that he did not at least partially explore. Sometimes just locating a wreck took weeks. "Five miles below Cairo, I searched the river bottom for the wreck of the 'Neptune,' for more than sixty days, in a distance of three miles," he later recalled. "My boat was held by a long anchor line, and was swung from side to side of the channel, over a distance of five hundred feet, by side anchor lines, while I walked on the river bottom, under the bell, across the channel. The boat was then dropped twenty feet further down stream, and I then walked back again as she was hauled towards the other shore." In 1851, he walked the bottom at full flood, sixty-five feet below the surface. Had he repeated the feat the following day he would have been drowned, because passing driftwood tore the submarine from its moorings and carried it downstream.

Wrecking was as profitable as it was risky. The supply of wrecks was practically limitless, and both shippers and insurance underwriters willingly paid salvage fees ranging from 20 to 75 percent of the net value of the cargo. Moreover, anything that had been in the water for more than five years was free for the taking. Eads—now Captain Eads—soon commanded a flotilla of submarines. His success as a wrecker was the talk of the river towns from Pittsburgh and St. Paul to the Gulf of Mexico.[7]

Eads's underwater observations had also convinced him that neither rivermen nor scientists really understood the hydraulics of the great inland rivers. However empirical it might have been, conventional river lore lacked any foundation in scientific principle. Pilots merely reacted to the

7. For details of Eads's salvage methods, see Eads, *Addresses and Papers*, pp. 164, 496–97; Eads et al. v. the H. D. Brown, 8 Fed. Cas. 224 (Case No. 4232); Eads v. Brayelton, 22 Ark. 499, 79 Am. Dec. 88 (January 1861); *Davenport* (Iowa) *Gazette*, 28 November 1850.

river; they could neither predict nor control its behavior. The available scientific literature was only a little more helpful. Strong on contending theories but weak on reliable data, applied river hydraulics was still in its embryonic stage. What Eads did draw from the scientific literature, however, was the inspiring conviction that systematic knowledge *could* dispel the mysteries of channel and bar formation.[8]

Eads's particular concern was the incredible scouring action of the current, its ability even at low-water stages to cut deep channels and deposit new sandbars overnight. To emphasize the magnitude of potential scour, Eads often cited the case of the steamer *America*, which had run aground a hundred miles below Cairo in 1836. During the next twenty years, an island of sand and driftwood had formed over the wreck and had grown large enough to support a small farm. On its banks grew cottonwoods that were cut for cordwood to fuel passing steamboats. Nevertheless, just two floods washed the island entirely away. When Eads salvaged the wreck in 1856, "the main channel of the Mississippi was over it, . . . the hull . . . had been cut down by the action of the current at the bottom nearly forty feet below the level at which it had first rested; and the shore had receded from it . . . nearly half a mile."[9]

Over the years, Eads shaped his practical observations into a theory of scour. He insisted (currently accepted river hydraulics to the contrary) that the sediment-carrying capacity of a stream depended upon its rate of flow, modified by its depth. "A certain velocity gives to the stream the ability of holding in suspension a proportionate quantity of solid matter." Any slackening of the current caused a deposit, any increase a scour. Eads's notion of the equilibrium between current flow and sediment capacity (later confirmed by the effectiveness of his self-dredging South Pass jetties at the mouth of the Mississippi) explained the conditions he had observed on the bottom. It also enabled him to predict, and hence potentially to control, the otherwise awesome Mississippi. Its "freaks and caprices" now became intelligible as part of a larger natural order. "No grain of sand, be it ever

8. For a convenient summary of the "only partially and imperfectly understood . . . science of hydraulics as applied to rivers," see A. A. Humphreys and H. L. Abbott, *Report Upon the Physics and Hydraulics of the Mississippi River* (Philadelphia, 1861), pp. 184–220. See also Hunter Rouse and Simon Ince, *History of Hydraulics* (Iowa City, 1957), pp. 139–218.

9. Eads, *Addresses and Papers*, pp. 496–97.

so small, is borne onward through its devious channels to the sea, but obeys some law more fixed and unchangeable than any in the code of the Medes and Persians. No giant tree standing in solemn grandeur on its banks is made to bow its stately head beneath those dark waves and sweep onward to the Gulf, but does so in obedience to some one or more of those immutable rules which God in his goodness and wisdom has instituted for the governance of matter at rest and in motion." Inspired by God's wisdom, man might "curb and direct those mighty currents, . . . banish from their depths their dreadful terrors, and . . . make their fast waters the faithful and submissive servants of his will."[10]

By twentieth-century standards, Eads's pious faith in scientific absolutes seems as naive as his Victorian rhetoric seems stilted. But, for the mud clerk turned salvage captain, it was a sustaining faith that glorified natural phenomena as it celebrated man's ability to comprehend and control them. It established a tangible link between the practical and the theoretical, the secular and the divine. In the short run, his faith gave James Eads a commanding lead in the highly competitive salvage business. In the long run, it equipped him with the combination of knowledge and confidence he would need to bridge the Mississippi River.

Except for a three-year interlude between 1845 and 1848, Eads virtually lived on his submarines. He finally came ashore only because he had fallen in love. His desire to be with his new wife, Martha, and the need to settle down and assume the respectable role of a wealthy merchant's son-in-law prompted him to sell his interest in the salvage fleet and invest his fortune in the first glass factory west of the Mississippi. It was a financial disaster. Twenty-five thousand dollars in debt by 1848, Eads abandoned the glassworks, borrowed enough from friends to buy back an interest in the submarines, and returned to his natural element. Within a few months, the disastrous St. Louis riverfront fire of 1849 provided an unexpected harvest of valuable wrecks. By the late 1850s he had satisfied his creditors and rebuilt his fortune. Confident that he had mastered the inland waterways, Eads

10. *Daily Missouri Republican*, 13 February 1867. Controversy stormed around the South Pass Jetty project for years. See Eads, *Addresses and Papers*, pp. 20, 129–359; Elmer L. Corthell, *A History of the Jetties at the Mouth of the Mississippi River* (New York, 1880); and *Transactions of the American Society of Civil Engineers* 13 (October 1884):313–30, and 15 (April 1886):221–336.

boldly applied for a government contract to clear and maintain snag-and-wreck-free channels throughout the entire Mississippi-Missouri-Arkansas-Ohio river system.

Unfortunately, Eads's success as a wrecker had also wrecked his health. The heartbreak of losing his wife to cholera in 1852 was doubtless a contributing cause; so were hundreds of hours in the close atmosphere of the diving bell. Eads never understood the perils of too-rapid decompression, and what was later diagnosed as chronic tuberculosis was probably aggravated by caisson disease. But Eads's fundamental malady was stress. His personal motto was Drive On! He pushed himself physically, intellectually, and emotionally to the point of collapse. The outward self-assurance, the boundless energy, the apparently effortless mastery of technical details, the preoccupation with precision and exactitude all took their toll. Periodically, the engineer's exhausted body simply throttled his driving will. In 1857, his physician recommended a leisurely European vacation followed by retirement. For the next few years, Eads lived quietly in his spacious mansion on Compton Hill, south of the city, where he puttered in his garden, minded his investments, and settled into the comfortable posture of country gentleman and civic elder statesman.[11]

The firing on Fort Sumter in April 1861 propelled James Eads back into public life. For months he had been fretting over the fact that the Southerners were fortifying the lower Mississippi and its tributaries with forts and shore batteries. He was convinced that without a river navy, the Union could not possibly hold the West. He wrote his friend Edward Bates, Lincoln's attorney general, and urged prompt action. Soon Eads was called to Washington. He learned that Lincoln, too, recognized the strategic significance of the Mississippi. He also learned that his reputation as the leading expert on the western rivers had preceded him and that the president wanted him to devise a defense plan.

Eads proposed a fleet of ironclad, steam-driven gunboats. When the government invited competitive bids, he submitted an audacious proposal to construct seven six-hundred-ton ironclads of his own design and have them ready to arm within sixty-five days. Within two weeks, Eads and his old salvage partner, William Nelson, had a shipyard in operation at Caron-

11. Dorsey, *Road to the Sea*, pp. 26–48.

delet, just downstream from St. Louis. The first gunboat was ready in forty-five days. Although red tape and a shortage of materials slowed the delivery of the other gunboats, by the summer of 1863 Eads's sturdy navy of ironclads had secured the western rivers from Fort Henry on the Tennessee to Vicksburg on the Mississippi. The lower Mississippi was still vulnerable from the Gulf, however; and Eads worked feverishly on several seagoing vessels that incorporated his newly invented steam-driven rapid-fire gun turret. A year later, Eads's warships would secure the Union victory at Mobile Bay.[12]

But once again the strain had been too great. In January 1864 Eads's physician told him bluntly that he must either retire or die. The pattern of the fifties was repeating itself: periods of intense creativity and responsibility interrupted by utter physical and emotional collapse; frenzied activity on the river followed by recuperation abroad. He was only forty-four, comfortably wealthy, the leading authority on the inland waterways, and, thanks to the ironclads, a nationally recognized industrial entrepreneur. He might rest, but he could not retire.

* * * * *

The Mississippi still beckoned, all the more so now that postwar recovery waited on the resumption of the lucrative river trade. More than immediate economic realities were involved, however. Eads shared with many westerners a romantic vision of the region's special destiny. The Mississippi valley was the "garden of the world," a vast inland empire of farms and forests and prairies spanning half the continent and united by a great river system that ran from the Appalachians to the Rockies, from Minnesota to the Gulf. "The stream which in every direction penetrates this favored region, and is the grandest feature of North America, holds in its watery embrace the destinies of the American people," Eads declared in 1867. Prophetic faith in the river had been a basic article of the St. Louis civic creed since the days of Lewis and Clark. Convinced that superhuman forces were at work, St. Louisans felt secure in the faith that the whole

12. Areola H. Reinhardt, "The Gunboats of James B. Eads During The Civil War" (M.A. Thesis, Washington University, 1936); Harpur A. Gosnell, *Guns on the Western Rivers: The Story of River Gunboats in the Civil War* (Baton Rouge, 1949).

westward course of empire had been directed toward making their city the metropolis of the Mississippi valley and the gateway to the Far West. Late-blooming western towns like Chicago and Kansas City might have to rely on contrived resources like railroads and civic boosterism, but St. Louis had only to capitalize on its favored location. The natural waterways were the natural pathways of commerce.[13]

The mystique of the river had blinded the community's business leadership to the magnitude of the technological and economic changes taking place around them. For decades the nation's inland trade axis had been shifting. Thanks to the canal and the railroad, settlement and trade were no longer bound to follow the natural watercourses north and south. The completion of the Erie Canal in 1825 had provided an alternative water route from the eastern seaboard across the upper Midwest to Chicago and Duluth. Within a decade followed the railroads, stretching westward from the populous mid-Atlantic and New England states into the Old Northwest, reinforcing both internal migration patterns and emerging sectional political alignments. By the 1860s, Missouri found itself in the awkward position of a border state with southern sympathies and northern interests.

Some St. Louisans had sensed the drift of events by 1849, when a group of local capitalists had hosted a convention to promote a transcontinental railroad. Throughout the fifties there were recurring schemes for railroads and for a bridge spanning the Mississippi, but they were always frustrated by a failure of entrepreneurial imagination and by a Democratic state legislature that took a dim view of internal improvements. Although a continuous rail line from the East had reached Illinois Town (later East St. Louis) by 1857, talk of a bridge had come to nothing but hopeful proposals. Active railroad promotion in Missouri came too little and too late, and then it emphasized western or southern routes or short lines that merely served the immediate hinterland. Few of the former would be completed by the mid-1860s; all save one of the latter would be bankrupt. With only 983 miles of track laid by 1867, Missouri ranked fifteenth among the thirty-seven states.[14]

13. *Daily Missouri Republican*, 12, 13 February 1867. See also Henry Nash Smith, *Virgin Land: The American West as Symbol and Myth* (Cambridge, Mass., 1950).
14. R. S. Cotterill, "The National Railroad Convention in St. Louis, 1849," *Missouri Historical Review* 12 (July 1918):203–15; Wyatt W. Belcher, *The Economic*

The limiting effects of a river-bound business imagination had been clearly revealed by the St. Louis response to the first railroad bridge across the Mississippi, completed in 1856 at Rock Island, Illinois, by the Chicago and Rock Island Railroad. Rather than spurring the construction of a St. Louis bridge, the threat of an upstream rival sent local boatmen into court with suits charging that bridges across navigable waterways were public nuisances, navigation hazards, and unconstitutional restraints on interstate commerce. Even worse, they were crimes against nature. "A glance at the map," declared the St. Louis Merchants Exchange, "shows that the Mississippi is the natural channel between the far distant basins of the upper Mississippi and Minnesota valleys and the Atlantic Ocean." Arguing from bad geography and even worse constitutional law (Chief Justice Roger Taney had settled the issue in 1837 in the case of the Charles River Bridge), the boatmen failed to stop the Rock Island bridge in the courts. Later, they even tried, again unsuccessfully, to stop it with blasting powder.[15]

Throughout the fifties the river had still ruled. St. Louisans complained that overland trade became hopelessly bottlenecked at Illinois Town, waiting to be ferried to the Missouri side. They complained that it cost nearly half as much to ship a barrel of flour fifteen hundred feet across the river as it did to ship it upstream twelve hundred miles from New Orleans. They regularly lost money to spring floods and winter freezes, fog and collisions. Yet the boatmen still dominated the local economy. The Wiggins Ferry Company remained secure in its virtual monopoly and replied to critics by asserting that it could meet the demands of expanding commerce, even if it had to float dismembered trains across the Mississippi on special barges.[16]

As the national economy picked up momentum during the months after Appomattox, St. Louisans began to understand the costs of compla-

Rivalry Between St. Louis and Chicago, 1850–1880 (New York, 1947); James Neal Primm, *Economic Policy in the Development of a Western State: Missouri, 1820–1860* (Cambridge, Mass., 1954); J. Christopher Schnell, "Chicago Versus St. Louis: A Reassessment of the Great Rivalry," *Missouri Historical Review* 71 (April 1977):245–65.

15. Benedict K. Zorbrist, "Steamboat Men Versus Railroad Men: The First Bridging of the Mississippi River," *Missouri Historical Review* 59 (January 1956): 159–72; Woodward, *History of the St. Louis Bridge*, pp. 7–10; Stanley Kutler, *Privilege and Creative Destruction: The Charles River Bridge Case* (Philadelphia, 1971).

16. Schnell, "Chicago Versus St. Louis," pp. 245–65.

cency. In the 1850s, while they had remained loyal to what the local press now called the "old fogy Southern notion of business," upstart Chicago had surged ahead. Favored by a lakeside location and by relatively easy railroad gradients to the east, backed by New York capital and by powerful political allies like Stephen A. Douglas, Chicago had completed a continuous rail link with New York by 1854. By 1860 Chicago was a major rail center served by eleven lines and was already the commercial emporium of the upper Midwest. Illinois ranked second among the states in miles of track in operation. During the war years, as St. Louis languished without its customary southern river trade, Chicago had made further inroads and gained a commanding lead in bulk-grain handling and meat packing. Now Chicago entrepreneurs were bridging the Mississippi at Dubuque, Burlington, and Quincy and the Missouri at Kansas City, bypassing St. Louis entirely as they drove deep into what had historically been the city's trade region. By 1867 the Chicago press was jubilant, proclaiming that the railroads had "overturned the sovereignty of the rivers" and made Chicago "queen of the west." A St. Louis editor agreed, sadly, that geography had been undone by technology. "Rivers run only where nature pleases; railroads run wherever man pleases." The St. Louis downriver trade had turned out not to be part of some divine plan for the Garden of the World, but merely an accident of time confirmed by habit, profitable only "when you have Southern planters to deal with, and when they cannot deal anywhere else."[17]

In the winter of 1866–1867, bridge promotion suddenly took on new urgency as part of a belated commercial counterattack. St. Louis would beat Chicago at its own game. A bridge over the Mississippi would link the five eastern and three western railroads now converging on the city. It would draw the errant overland trade back to St. Louis and tie it forever to the inland waterways. A bridge was now a necessity, the key element in a civic crusade to recapture and perpetuate the river city's golden age, a tardy and ultimately futile effort to win back the commercial initiative Chicago had snatched away. The press whipped up local enthusiasm. Civic boosters—now obviously running scared—frantically celebrated regional pride

17. *Daily Missouri Democrat*, 23 January, 16 July 1867; Henry V. Poor, *Manual of the Railroads of the United States for 1868–69* (New York, 1868), pp. 17–21; George Rogers Taylor and Irene Neu, *The American Railroad Network, 1861–1890* (Cambridge, Mass., 1956), Bessie L. Pierce, *A History of Chicago*, 3 vols. (New York, 1937–1957), 2:35–117.

and cosmic destiny and proclaimed St. Louis "the future Great City of the World." There were even fantasies that soon St. Louis would become the focal point of national aspiration and replace Washington, D.C., as the nation's capital.[18]

Bridge schemes multiplied in an atmosphere of desperate optimism. John A. Roebling, acclaimed for his Niagara and Cincinnati suspension bridges, revived a combined suspension and arch design he had originally submitted in 1855. Taking the opposite approach, the Mississippi Submerged Tubular Bridge Company proposed a tunnel. The St. Louis city engineer, Truman Homer, issued a report condemning suspension bridges and urged the adoption of a rectangular wrought-iron tubular girder patterned after Robert Stephenson's Britannia Bridge in Wales.

The most ambitious and ominous proposal came from Lucius Boomer of Chicago. St. Louis promoters had previously secured state and federal authorization for the St. Louis and Illinois Bridge Company to span the river at St. Louis, but their efforts had gone no further. Boomer and his Chicago backers now pressured the Illinois legislature to rescind the existing charter and grant his own Illinois and St. Louis Bridge Company a twenty-five year exclusive right to build from the Illinois shore. It was a shrewd strategy. If the Chicago capitalists actually built the bridge, they would drain away toll revenues from St. Louis and gain a potential stranglehold on the city's commercial future. If they chose to do nothing or transferred their monopoly privileges to steamboat or ferry interests, they could block all bridge construction at St. Louis for a quarter-century. There were plausible rumors in St. Louis that Boomer, the Wiggins Ferry Company, and the boatmen had conspired to advance their own interests at the expense of community and regional development.[19]

18. *Edwards Annual Director to the . . . city of St. Louis for 1866* (St. Louis, 1866), p. 1029; *Daily Missouri Democrat*, 24, 29 December 1866, 5, 6, 12 February 1867; Logan Reavis, *A Change of National Empire; or, Arguments in Favor of the Removal of the National Capitol from Washington City to the Mississippi Valley* (St. Louis, 1869); James Parton, "The City of St. Louis," *Atlantic Monthly* 19 (June 1867):655–72; Logan Reavis, *Saint Louis, the Future Great City of the World* (St. Louis, 1870).

19. John A. Roebling, *Long and Short Span Railroad Bridges* (New York, 1869); Truman Homer, *Reports of the City Engineer and Special Committee to the Board of Common Council of the City of St. Louis, in Relation to a Bridge Across the Mississippi River, at St. Louis* (St. Louis, 1865).

Up to now, James Eads had shown little if any interest in a St. Louis bridge. Though influential in local affairs, a leading member of both the Merchants Exchange and the newly formed Board of Trade, he had not been an active promoter of the St. Louis and Illinois Bridge Company. This was not surprising. His lifelong interest had been in removing river obstacles, not in adding one; furthermore, he knew nothing in particular about bridge engineering. But the trade rivalry with Chicago could lead to civic catastrophe. The danger that the bridge might either be thwarted entirely or that it might "fall into the hands of the enemies of St. Louis" finally moved him to action. In January 1867, Eads urged the Merchants Exchange to encourage the local bridge company. A month later, he and other 'Change members authorized a special committee to visit Springfield and lobby against the passage of the Boomer bridge bill. Thanks to the support of southern Illinois legislators, who saw their interests bound with those of St. Louis, the delegation was moderately successful. Boomer's charter did pass, but his construction monopoly would lapse if the bridge was not begun within two years and completed within five more. Illinois lawmakers evidently hoped for an eventual settlement with the St. Louis promoters as well and authorized Boomer's company to merge with any similar bridge corporation chartered in Missouri.[20]

The immediate effect of the Boomer bill was to convert a general urban rivalry into a specific contest between competing bridge companies. It was never clear whether Boomer's real intent was to build a bridge or to prevent one, but he reassured the public early in March by making preliminary soundings on the riverfront and by revealing his bridge design. The bridge would consist of six wrought-iron spans supported on shore abutments and river piers and would incorporate the lattice-girder truss design recently patented by S. S. Post.[21]

In St. Louis, Boomer's engineering was as suspect as his politics. The community still vividly recalled the disastrous train wreck of 1855, when a flimsy Boomer-built bridge over the Gasconade River had collapsed and

20. *Daily Missouri Democrat*, 18, 25 January, 13, 16, 18 February, 11 March, 6 April 1867; *Daily Missouri Republican*, 17 February, 4, 27 March, 11 April 1867.

21. For a sketch and critique of Boomer's bridge, see *Engineering* 6 (24 July 1868):75, 82, and 6 (7 August 1868): 116–17. The Union Pacific Railroad's eleven-span Post truss over the Missouri between Omaha and Council Bluffs collapsed in 1877, just five years after its completion. See Condit, *American Building*, pp. 103–4.

wiped out a substantial portion of the city's commercial and political elite en route to a railroad convention in Jefferson City. Many of Eads's friends had been killed, including his old salvage partner, Calvin Chase. Moreover, Eads was convinced that Boomer's river piers would never withstand the undermining effects of scour.[22]

Within the month Eads was circulating sketches of an alternative bridge design. By early May, he had become a director of the St. Louis and Illinois Bridge Company and had been appointed its chief engineer. Eads had the backing of St. Louis business leaders and could appeal to civic loyalty in the scramble for public support and investment capital. Yet Boomer had a head start, substantial financial resources, and the apparent endorsement of professional engineers. In an effort to discredit Eads, in August 1867 Boomer hosted a convention of civil engineers in St. Louis and, amid lavish entertainments, asked them to review the merits of the rival bridge proposals. They obligingly praised Boomer's design (S. S. Post headed the committee on superstructure), and rejected Eads's alternative without even a cursory examination. They cautioned investors that there was "no engineering precedent" for what Eads proposed to do, that his "erratic" notions and "eccentricities" would lead him "either to attempt impossibilities, or, what is more likely, to venture too far in an untried field of labor."[23] Eads retorted that Boomer's engineers had dismissed him without a fair hearing. Furthermore, engineering drew its strength from scientific principles, not from historical precedent; its vision was directed toward what could be rather than what had been. "Must we admit that because a thing never has been done, it never can be?" he asked.[24]

Boomer's campaign backfired. His heavy-handed tactics only consolidated Eads's support, and the transparent collusion between Boomer and his guest engineers destroyed whatever credibility their judgments might otherwise have had. Within a few months it was apparent that public confidence had swung toward Eads. By January 1868 Boomer and his back-

22. *Daily Missouri Democrat*, 2, 3 November 1855; Eads, *Addresses and Papers*, pp. 496–501.
23. *Daily Missouri Democrat*, 18 January, 27 March, 12 April, 16 July 1867; *Daily Missouri Republican*, 16, 17 February 1867; Lucius Boomer, *Proceedings and Report of the Board of Civil Engineers* (St. Louis, 1867), pp. 77–79.
24. Eads, *Addresses and Papers*, pp. 510–16; Woodward, *History of the St. Louis Bridge*, pp. 19–24.

Overview of the proposed bridge, design of 1867.

ers had tired of the game and met with Eads to negotiate a merger. The consolidation agreement combined the stock of the two companies, created a new board of directors representing each firm equally, retained the Chicago company's name, and adopted Eads's design. By midsummer, Lucius Boomer had departed, leaving Eads a free hand to proceed on his bridge.

* * * * *

Eads apparently had settled upon the basic design in February or March 1867. He had recruited a remarkable corps of assistants, most of them émigré engineers with degrees from prestigious German universities, and with their help spent the spring refining structural details and polishing the computations. Charles Pfeifer, who had written a prize thesis on the theory of arch-bridge design, and Henry Flad, another German engineer of wide practical experience, led the self-taught Eads through the complexities of stress analysis. Eads also took the precaution of having their calculations verified by William Chauvenet, a noted mathematician and the chancellor of Washington University. The directors of the company accepted the plan in July. Two months later, Eads publicly displayed a set of drawings at the 'Change.[25]

25. "Mathematical Investigations and Computations for the Construction of the Illinois and St. Louis Bridge," appendix to James B. Eads, *Report of the Engineer-in-Chief of the Illinois and St. Louis Bridge Co.* (St. Louis, 1868). The standard McHenry edition of Eads, *Addresses and Papers*, omits the technical appendixes. See also Charles Pfeifer, "Calculations of Strains in Arch Bridges," *Van Nostrand's Eclectic Engineering Magazine* 14 (June 1876):481–96; Henry Flad's obituary of Pfeifer in *Daily Missouri Democrat*, 18 February 1883; and Carl Gayler, "Eads Bridge," in *German Engineers of Early St. Louis and Their Works* (St. Louis, 1915), p. 6.

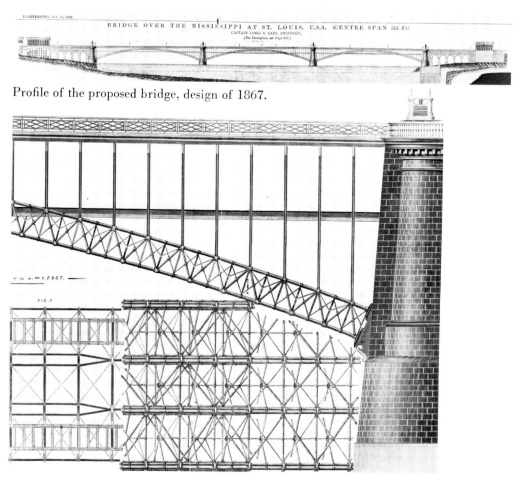

Profile of the proposed bridge, design of 1867.

Detail, arches, design of 1867.

The drawings showed a triple-span arch with two side spans of 497 feet each and a center span of 515, all supported by two shore abutments and two river piers. Four pairs of tubular steel arches, their upper and lower members set eight feet apart, extended from pier to pier and supported a double deck for railroad and vehicular traffic. Each arch member in turn consisted of two tubes, each nine inches in diameter, set side by side. Thus each span was composed of sixteen tubular arched ribs (see above). The ribs, manufactured in eight-foot sections, would be bolted together during construction. Several complex systems of diagonal bracing kept all the ribs

in their proper relative positions, maintaining the form of the arch and eliminating sway. The arch ribs terminated in massive skewback plates, which were in turn bolted solidly to the piers and abutments. The bridge was thus of the fixed-arch type, an indeterminate structure whose behavior under load could not be accurately calculated in advance. The apparently smooth curve of the arch was an optical illusion. Each rib section was perfectly straight, but with each end cut at a slight angle. Butted together end to end, the tubes appeared to form an arc when in reality they were segments of a polygon with nearly eight hundred sides.

From each abutment, masonry approaches, pierced by tall arches, carried traffic to the bridge. On the Missouri side the upper or road deck fed directly into Washington Avenue, affording easy access from the bridge to the heart of the city. The lower or train deck entered a tunnel nearly a mile long. Trains would pass under the crowded business district and resurface in the vacant wastes of Mill Creek valley near the site of a projected union depot. On the Illinois side, the high masonry approach led in turn to long, gently sloping trestles that carried rail and street traffic back to ground level.

Architecturally, the bridge just missed elegance. A number of architectural embellishments, such as S-curved cornices on the skewback plates, cluttered the natural simplicity of the basic form. So did the heroic statuary looming atop each pier. The train deck crossed below the crown of the lower arch, spoiling a graceful curve with a starkly horizontal line.[26] These Victorian distractions were probably the work of George I. Barnett, Eads's friend and a leading local architect of the Italianate school. Eads, who knew even less about architecture than he did about bridges, had turned to Barnett for advice. The arches of the masonry approaches were almost a Barnett signature; so was the penchant for eclectic ornamentation. The stylistic confusion of the overall structure suggested that Eads did not yet have a vision of the bridge as an artistic whole. Nevertheless, the local press was enthusiastic. "What a triumph for St. Louis," exclaimed the *Democrat*; "the noblest river, the most glorious bridge, and the finest engineer in the world." National journals echoed local sentiments, as did the professional

26. Eads Bridge Abutment Elevation, ca. July 1867, Eads Bridge Engineering Drawings, Washington University Archives, St. Louis, Mo. See the sketches in Eads, *Report of the Engineer-in-Chief*, 1868, and in *Engineering* 6 (16 October 1868):279, 344.

engineering community. Zerah Colburn, editor of the influential English journal *Engineering*, pronounced the bridge "at once original in conception, and bolder in design than any similar structure which has yet been attempted."[27]

The sources of Eads's design were varied and confusing; varied because of the complex interplay between politics and economics, technology and aesthetics, necessity and desire; and confusing because Eads's public acknowledgments often obscured nearly as much as they revealed. In the first instance, his options were limited by the accumulation of state and federal charters, which stipulated that the bridge could be neither suspension nor draw, that it could not be made of wood, and that it must carry rail as well as vehicular traffic. They also stipulated that the bridge must have either one span of five hundred feet or two spans of at least two hundred and fifty. The lowest part of the superstructure must be at least fifty feet above the City Directrix, the local survey base line ("low water" was thirty-four feet below the Directrix; the highest flood yet recorded had crested at seven and a half feet above). The specified location required Eads to span the river from the low floodplain of the Illinois shore to the high Missouri bank without exceeding the allowable gradient for railroad tracks and to provide easy vehicular access from the city without also routing dozens of trains daily through the middle of the business district.

The river itself had imposed the most difficult design problems, but these were problems that Eads was uniquely equipped to solve. More than Lucius Boomer or any of the other bridge promoters, Eads understood and respected the river's turbulent currents, massive winter ice gorges, and violent scouring action. At the bridge site, the Mississippi was approximately fifteen hundred feet wide. Through this relatively narrow channel surged the runoff from a drainage basin of nearly 7 million square miles. The velocity of the current ranged from four feet per second at low water to more

27. *Daily Missouri Democrat*, 16 July 1867; *Missouri Republican*, 5 August 1867; *Debow's Review*, n.s. 4 (July-August 1867): 122–24; *Engineering* 6 (7 August 1868):121–27, 279, 285–86; Woodward, *History of the St. Louis Bridge*, p. 114. For comparative examples of Barnett's work, see his proposed design for the St. Louis Union Station in William Taussig, *Development of St. Louis Terminals* (St. Louis, 1894), appendix; and John A. Bryan, *Missouri's Contributions to American Architecture* (St. Louis, 1928), pp. 36, 40, 62. For biographical details, see John A. Bryan, *Henry Shaw, Botanist Benefactor, and George Ingham Barnett; Co-Workers in American Culture* (Chillicothe, Mo., 1975).

than twelve at high water. At the normal water stage, 1.68 million gallons passed by each second, while at full flood the discharge might be four times as great.[28]

The piers of the bridge would have to withstand the awesome force of the river while supporting the superstructure and thousands of tons of moving traffic. They would be secure only if they rested directly on the bedrock far below the unstable sediments of the riverbed. Unfortunately, the bedrock, only forty feet below the surface at St. Louis, sloped downward to the east until it lay more than a hundred feet below the Illinois shore. No one had ever attempted to sink caissons to such depths, certainly not beneath the surface of a river given to sudden flash flooding.

Technical necessity dictated that Eads sink as few river piers as possible. So did the political desirability of placating the boatmen by reducing the number of permanent channel obstructions to the minimum. Using relatively few supporting piers required that the spans in the superstructure be relatively long, thus adding technical sanction to the statutory requirements. Eads's only available options were to adopt either a metallic truss or a metallic arch.

Truss bridges were in vogue. Both the theoretical and practical mathematics of truss design were straightforward. Truss bridges could be assembled quickly from relatively small components that were well within the production capabilities of the existing iron industry. They could be adapted to a wide range of local circumstances. Like the balloon-frame house, the truss bridge suited the needs of pragmatic Americans in a hurry to subdue a continent. The preceding decades had seen a proliferation of truss designs, ranging from the simple triangular geometry of the Warren truss to the busy complexities of the Bollman and Fink. If carefully assembled from quality materials, iron trusses were perfectly adequate for spans of up to about four hundred feet. The long-span railroad bridge, however, was rapidly straining truss-bridge technology beyond its limits. The form was not at fault; problems arose from a lack of quality control in the manufacture of materials and from a want of precision in their assembly. As trains got longer, heavier, and faster, the greater loads increased the forces of tension and compression on the various members of the truss. As the working stresses

28. Woodward, *History of the St. Louis Bridge*, pp. 1–6.

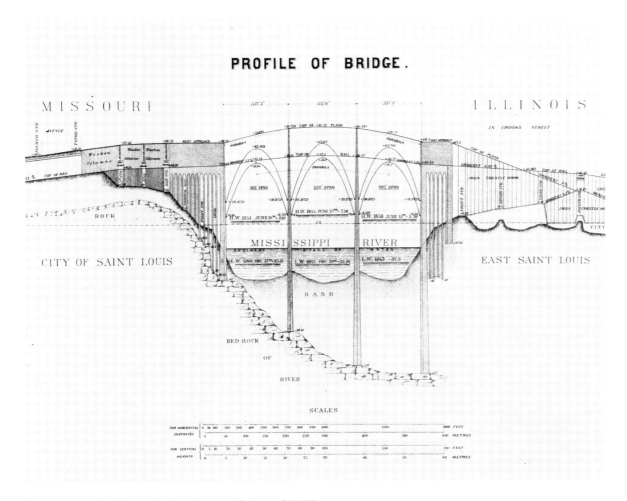

Cross section, bridge and river bottom, design of 1867.

approached nearer and nearer the elastic limits of wrought and cast iron, the size of the structural members had to be correspondingly increased, the calculations on which they were based had to be ever more precise, their assembly ever more exact. Longer spans also meant greater wind resistance, greater fluctuations in length due to changes in temperature, and an increasing tendency for members to buckle. The motion of heavily laden trains added still further (and extremely complex) stresses, while the constant vibration produced dangerous metal fatigue. With little more than

empirical experience to guide them, engineers guarded against disaster by grossly overbuilding. By 1877, the iron truss would climax in such structures as the 517-foot central span of the Cincinnati Southern Bridge over the Ohio. Meanwhile, iron railroad truss spans were collapsing at such an appalling rate that in 1873 the American Society of Civil Engineers called for an inquiry.[29]

Eads was an outsider; since he had never before built a bridge, he was free to approach the problem with the same freshness and inventiveness he had displayed in his previous undertakings. Adhering to the engineer's first principle of doing the most with the least, his overall design strategy was remarkably conservative: to erect the strongest possible bridge at the least possible cost and to do so in a manner that did not seriously interfere with passing river traffic. His solution, however, was typically innovative. Eads decided to execute the ancient and familiar form of the arch in cast steel, a new and virtually unknown structural material.

The arch had been utilized in short-span masonry and wooden bridges since antiquity. Louis Wernwag of Philadelphia had even erected a spectacular wooden arch of 340 feet—probably the longest wooden span ever built—across the Schuylkill in 1812. However, there were relatively few precedents for long-span metallic arches. Thomas Paine had pioneered the type in the 1780s as he turned his talents from revolutionary propaganda to civil engineering. On the advice of Benjamin Franklin, he had left America to patent his designs abroad but had been distracted by the French Revolution before he actually built a bridge. Others appropriated his design for several English bridges, the first being the 236-foot Sunderland Bridge over the River Wear in the 1790s. The Scottish engineer Thomas Telford had soon followed with a number of graceful tubular iron arches, including a breathtaking but technically plausible plan to bridge the Thames with a single cast-iron arch of 600 feet. During the next half-century, several metallic arches were built on the Continent as well. French and German engineers elaborated the mathematical theory of the ribbed arch, particularly of the two-hinged type in which the ends of the arch were free to pivot on bearings at the abutments.

American bridgebuilders had shown comparatively little interest in

29. *Transactions of the American Society of Civil Engineers* 4 (March, 1875): 122–35. *Scientific American* 28 (May 24, 1873): 321.

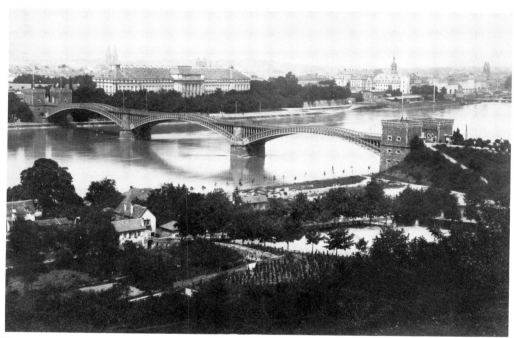

The Koblenz bridge, completed 1864. Photographer unknown.

the tubular metallic arch. The first American example had bridged a small creek in Pennsylvania in 1836. The second was a clever double-duty arch carrying Pennsylvania Avenue across Rock Creek in the nation's capital; in this bridge the arch tubes also served as water mains. The third had spanned the Schuylkill at Philadelphia during the Civil War. These American bridges were hardly convincing precedents for what Eads proposed to do.[30] He turned to more promising models abroad. Telford's bridges had amply demonstrated the structural and architectural potential of the tubular arch. The Scotsman's proposed (but never erected) 600-foot Thames bridge seemed to Eads convincing proof that long-span tubular arches were feasible. The immediate inspiration for the St. Louis bridge, however, was the triple-arch railroad bridge across the Rhine at Koblenz, completed in 1864. Given the heavily Germanic composition of his engineering staff and the dominance of German culture in St. Louis, it was only appropriate

30. Jacques Antoine Charles Bresse, *Cours de mécanique appliquée, professé à l'école impériale des ponts et chaussées*, 3 vols. (Paris, 1859–1865); Condit, *American Building Art*, pp. 182–85.

that Eads was drawn to a Prussian bridge. Charles Pfeifer, who had only recently arrived from Stuttgart, may well have called the bridge to Eads's attention. Pfeifer based his first series of calculations on the equations developed for Koblenz and modeled his first sketches directly on the German bridge.[31]

In their overall visual aspect, the two bridges were strikingly similar. A casual observer might well have concluded that Eads had merely added a second deck and adjusted the dimensions to the particular requirements of the St. Louis site. Closer inspection revealed that the Koblenz bridge was actually quite different in structural detail, so much so that Eads was probably justified in downplaying its influence until his own bridge was nearly completed. The 317-foot Koblenz arches were typically European wrought-iron lattice girders rather than steel tubes. The bridge was erected as a two-hinged arch and later wedged rigidly into fixed-arch form. It was a single-deck, double-track railroad bridge, lacking an upper deck for vehicular traffic. Its river piers had to contend only with the Rhine, not the Mississippi.[32]

Although Eads had appropriated the "general style and character" of the Koblenz bridge, he was actually less interested in engineering precedent than in engineering economics, less influenced by what others had done than by what he knew he could do. "Engineering precedents have nothing to do with the question of length of span in a bridge," he declared. "It is a money question altogether. The problem to be solved is simply, what length of span will pay best? This being decided, and profit enough assured to justify the outlay, engineering skill and knowledge will be found fully equal to its accomplishment, no matter what may be the length required."[33]

31. Eads, *Report of the Engineer-in-Chief*, 1868, appendix, pp. 3–4; James B. Eads, "Upright Arched Bridges," *Transactions of the American Society of Civil Engineers* 3 (1874):319; Casimir Constable, "Arched Beams," *Transactions of the American Society of Civil Engineers* 1 (1868–1871):375–91; *Daily Missouri Democrat*, 18 February 1883; Carl Gayler, "Engineering History of St. Louis," typescript address, 20 February 1929, Carl Gayler Papers, Missouri Historical Society.

32. M. E. Hartwich, "Erweiterungsbauten der Rheinischen Eisenbahn. Erste Abtheilung: Rheinbrücke bei Coblenz," *Zeitschrift für Bauwesen* 14 (1864): 530–78; "Die Brücke über den Rhein bei Coblenz," *Zeitschrift des vereins deutscher Ingenieure* 9 (September 1865):578–84; M. Romain Morandier, *Traité de la construction des ponts et viaducs* (Paris, 1888), pp. 939–48; *Engineering* 3 (7 June 1867):586; *Missouri Republican*, 5 August 1867.

33. Eads, *Addresses and Papers*, p. 513.

Eads's easy confidence rested on his belief that he had discovered the universal formula for erecting long-span railroad bridges at the least possible cost. He insisted that the upright steel arch was inherently the most economical form for any bridge of any span in any location. It was cheaper than a truss, cheaper even than the suspension span. Although Eads advanced his claim as an absolute, iron law of engineering, it was at least debatable. Numerous critics accused Eads of claiming too much, of mistaking a local phenomenon for a law of nature. Eads, stubborn and disputatious in matters of technical judgment, never retreated; he continued to debate the issue for years at professional meetings and in the technical press.[34]

His immediate problem was not to convince his professional peers, but to explain and justify the bridge to the laymen who hopefully would finance it. In his elaborate first annual report as chief engineer, issued in May 1868, Eads presented the ribbed arch as the product of a series of simplifications, as a return from the unnecessary complexities of the truss to a simple, elemental form that combined grace and strength with economy.

All bridges supported themselves and their loads by opposing the forces of tension and compression. The challenge of bridge design was to arrange the structural members so that they balanced tension and compression in the most efficient, and hence the most economical, manner. The simplest truss, Eads explained, was a triangular form (see Figure 1) in which the load subjected the top members A and B to a crushing, or

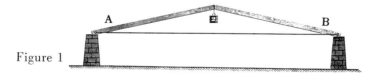

Figure 1

compressive, strain, while the bottom chord was in tension.[35] The bottom and top members held each other in equilibrium and transferred the weight of the load and of the structure itself to the piers. This simple truss

34. See *Journal of the Franklin Institute* 86 (September 1868):147–52, and the discussions in *Transactions of the American Society of Civil Engineers* 3 and 4 (1874–1875).

35. The following discussion is based upon Eads's presentation in *Report of the Engineer-in-Chief*, 1868. See Eads, *Addresses and Papers*, pp. 487–94.

sufficed for short spans, but in long spans the top members tended to sag from their own weight and so destroyed the structural integrity of the system. The usual solution was to complicate the truss with a third member C on the top (see Figure 2) and to add braces D and tie-rods E. Members A, B, and C carried the compressive forces of the load, while the braces D, tie-rods E, and the bottom chord maintained the shape of the truss. The longer the truss, the more supplementary bracing it required.

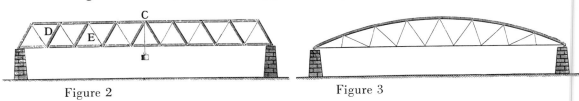

Figure 2 Figure 3

It was possible to economize on material without sacrificing load capacity by curving the compressive members into a bowstring girder (see Figure 3). The top and bottom members were now subjected to almost equal strain, and the two required approximately the same amount of material. The form was still uneconomical, however, because the bottom chord merely kept the bow from spreading at the ends. It nearly doubled the weight and cost of the superstructure without increasing its load capacity.

Eads proposed to simplify the bowstring by dispensing with the string. If the compressive member of the arch (see Figure 4) was placed between abutments strong enough to withstand the outward force otherwise restrained by the "string," or bottom chord, the latter became superfluous. In the case of the St. Louis bridge, this would result in a saving of nearly 1350 tons of steel in the superstructure. The size of the abutments would

Figure 4

have to be increased to resist the outward thrust of the arch (in the bowstring they merely supported a vertical load). But if the cost of the masonry was less than the cost of the steel it replaced, the result was a net saving. In theory such an arch, if parabolic in form and uniformly loaded through-

out its length, would be self-supporting and require no supplementary bracing.

In practice, the stringless bow flattened under a moving load at A and humped at B (see Figure 5). Since the strength of the arch depended on the integrity of its form, it became necessary to brace it against distortion. The conventional method was by adding spandrel bracing suspended from an additional member AB which extended over the entire span (see Figure 6). Once again, this member added weight and cost without contributing to the load capacity.

Figure 5 Figure 6

Eads argued that the best solution was to divide the material of a single arch into two ribs and place them a few feet apart in the vertical plane, crossbracing them to maintain their form and relative positions (see Figure 7). The rib bracing would require a fraction of the material needed for spandrel bracing. Wind-truss bracing, required to prevent sidesway, would likewise require less material than in conventional truss designs. Assuming a gross load (bridge traffic plus the weight of the superstructure) of 7.2 tons per lineal foot, Eads concluded that ribs set only eight feet apart would easily maintain the form of an arch over five hundred feet long.

Figure 7

Eads's metallurgy was less certain than his mechanics. Looking back from the twentieth century, where steel is a routine feature of everyday life, it is hard to appreciate the degree to which he was gambling on metallurgical unknowns. In 1867 structural steel was a novelty. The staple

structural material of the nineteenth century had not been steel, but rather wrought or cast iron. The former was malleable but relatively soft, the latter extremely hard but brittle. Conventional engineering practice took advantage of these characteristics by utilizing wrought iron for members in tension and cast iron for those in compression. What Eads required was a material that was stronger than either but combined the advantages of both.

Steel, a compound of iron and carbon, had been known for centuries. But it had always been expensive, virtually handmade in small batches by artisans who jealously guarded the mystery of their craft, and used only for cutting tools and similar items requiring a combination of hardness, toughness, and resiliency. Within a decade, the recently developed Bessemer and open-hearth processes would revolutionize steel production, making it possible for the first time to manufacture high-grade, low-cost steel in large quantities. American steel production, which totaled only 22,000 tons in 1867, would increase four-fold in as many years and reach nearly 242,000 tons by 1874.[36] In the meantime, the industry was adrift in metallurgical chaos, no longer alchemy but not yet industrial science. The confusion of traditional methods and new processes rendered old definitions obsolete; neither steelmakers nor engineers were certain what steel was, much less how it might behave in any given structural application.[37]

Eads probably knew most of what there was to know about structural steel in 1867. There was evidence that he had consulted the leading authorities both in America and abroad. Yet even he admitted that the use of structural steel was "comparatively in its infancy." Few other engineers would have felt comfortable building a long-span steel bridge on such a narrow foundation of knowledge.

Eads could point to reassuring data on the relative strength of iron

36. James M. Swank, *History of the Manufacture of Iron in All Ages* (Philadelphia, 1892), p. 511; Etling E. Morison, "Almost the Greatest Invention," *Men, Machines, and Modern Times* (Cambridge, Mass., 1966), pp. 123–205.

37. "Quackery in Steel-Making," *Engineering* 6 (18 December 1868):543; Henry M. Howe, "What is Steel?," *Engineering and Mining Journal* 20 (28 August 1875):213 (4 September 1875):235–36 (11 September 1875):258–59 (18 September 1875):282–83; Frederick Prime, Jr., "What Steel Is," *Engineering and Mining Journal* 21 (17 June 1876):584–85; A. L. Holley, "Tests of Steel," *Engineering and Mining Journal* 16 (11 November 1873):316–17; "The Meanings of Steel," *Engineering and Mining Journal* 15 (19 August 1873):120–21; William F. Durfee, "The Manufacture of Steel," *Popular Science Monthly* 40 (November 1891):15–40.

and steel. Each material had an inherent limit of elasticity (a point beyond which it could not be stressed without permanent deformation, or "set") and an ultimate strength (a point beyond which it failed). The English metallurgist William Fairbairn had recently found that steel, with an ultimate strength of nearly one hundred thousand pounds per square inch, was nearly twice as strong as the best wrought iron. Better yet was his demonstration that steel in compression was more than twice as strong as steel in tension.[38] Its great compressive strength made steel the ideal material for an upright arch. Moreover, wrote Eads, steel in compression had an additional built-in safety factor that was missing when the material was used in tension. A tension member pulled beyond its elastic limit stretched. It became thinner in cross section, hence weaker in tensile strength. Each subsequent strain had a cumulative effect, progressively weakening the member until it failed. In a compression member the effect was reversed. Each stress beyond the elastic limit squashed the member, reducing its length but increasing its cross section and thereby increasing its load capacity. Each strain actually made the arch stronger. Eads's reasoning here was fallacious, because it assumed that the compression member was perfectly malleable and that the foreshortening of the stressed member would not in turn overstress adjacent parts of the structure. His theory was never put to a practical test, however, because his bridge was built to sustain six times its maximum possible load.[39]

Leading American and European manufacturers had assured Eads that they could supply steel to his specifications, which in the case of the arch tubes called for elastic limits of 60,000 pounds under compression and 40,000 under tension, with an ultimate tensile strength of 100,000. Although these were reasonably conservative specifications, Eads made doubly sure by stipulating the modulus of elasticity, a mathematical expression of the ratio between stress and deformation and a far more revealing figure than the absolute value for elastic limit or ultimate strength. Eads knew that steelmakers were unaccustomed to such precise specifications and that customary shop practice allowed wide latitude in quality control. Consequently, he concluded his presentation of the superstructure with the an-

38. Eads, *Addresses and Papers*, pp. 521, 527; William Fairbairn, "Experimental Researches on the Mechanical Properties of Steel," *Annual Report of the British Association for the Advancement of Science, 1867* (London, 1868), pp. 161–274.

39. Eads, *Addresses and Papers*, pp. 519–21.

nouncement that he was building a special machine with which to test every piece of steel that went into the bridge.[40]

Eads's bridge of 1867–1868, so elaborately presented and warmly received, was never built. Hurriedly conceived under competitive pressure from the rival bridge company, the design was far from perfected when Eads revealed it to the public. During the next four years of construction, Eads and his staff recalculated and redesigned the structure in a number of subtle ways. The public hardly noticed the changes, particularly because publishers continued to illustrate later bridge articles with engravings dating from 1868. Eads himself added to the confusion over the two bridges—the bridge as originally designed and the bridge as actually built—by certifying that Camille Dry's famous but innaccurate birds-eye view of the bridge was an "excellent and faithful representation."[41]

The changes in design were dictated by both engineering and aesthetics. Eads slightly lengthened the spans, from 497 and 515 feet to 502 and 520 feet, and altered the profile of the arches so that the train deck no longer crossed below the crown. He substituted single eighteen-inch-diameter rib members for the double nine-inch ribs originally specified and increased both their length and vertical separation from eight feet to twelve. He widened the bridge from fifty feet to fifty-four, and likewise enlarged the tunnel to accommodate George Pullman's new Palace Parlor Cars. Prompted by a tornado that swept through the construction site in the spring of 1871, he redesigned and considerably strengthened the wind-truss bracing. Stylistically, Eads stripped the bridge clean of its architectural frills; George Barnett's heroic statuary died on the drawing board.

* * * * *

Work actually had begun on the west abutment in August 1867, months before it was certain whether the bridge would be Eads's or Boom-

40. James B. Eads, "Specifications for Cast-Steel Work," *Chief Engineer's Report, 1870* (St. Louis, 1870), appendix; Eads, *Addresses and Papers*, p. 528. Cf. Olaus Henrici, *Skeleton Structures, Especially in their Application to the Building of Steel and Iron Bridges* (New York, 1867), pp. 76–77, 89–90.

41. Camille N. Dry and Richard J. Compton, *Pictorial St. Louis, The Great Metropolis of the Mississippi Valley* (St. Louis, 1875), frontispiece.

er's. Progress had been sporadic during the winter, however; when Eads's men had sunk the cofferdam down through the levee, they had encountered unexpected strata of sunken steamboats and other harbor junk that had had to be cleared away before the excavation could proceed. At length they had fitted a pile driver with a huge steel-tipped chisel and had sheared through hulls and old boilers by brute force. It was not until the following February that they reached bedrock, forty-seven feet below the City Directrix, and Eads personally laid the first foundation stone of his bridge. Though the event had great symbolic significance, it was modestly advertised and minimally attended. As Eads maneuvered the great limestone block into its nest of mortar, there was no fanfare, no speeches; the disappointed local press dismissed it as "not a very exciting operation."[42]

Later generations would picture an energetic James Eads at the construction site daily, inspiring his men and personally supervising every aspect of the work. Actually, he was out of town much of the time and came close to abandoning the project before construction was well underway. During the hectic months of designing and promoting the bridge, Eads had once again pushed his body beyond its elastic limit. Preparing his first annual report had left him near the point of collapse. In July he tried to quit, going so far as to recruit Octave Chanute, then building a bridge at Kansas City, to serve as his replacement. When the directors refused to accept his outright resignation, he took an extended leave of absence and sailed for Europe, leaving the fate of the bridge in the hands of his assistants. Work all but ceased until after the engineer, feeling much refreshed, returned to St. Louis eleven months later. During the next six years of bridge construction, Eads would repeat his familiar cycle of frantic activity interrupted by periods of exhaustion. He did supervise closely the sinking of the piers and abutments (though Charles Pfeifer was formally in charge), but he was elsewhere during many of the critical phases of superstructure construction. In his absence, Eads's corps of assistants, particularly Pfeifer, Henry Flad, Milnor Roberts, and Theodore Cooper, took charge. They deserved much of the credit for Eads's reputation as a bridge engineer.[43]

42. *Missouri Republican*, 26 February 1868.
43. Octave Chanute to James B. Eads, 27 June 1868, Octave Chanute Papers, Library of Congress, Washington, D.C.; Woodward, *History of the St. Louis Bridge*, pp. 55–57.

Bridge company business also kept Eads on the road. He was the axis of the enterprise, the company's prime contractor and financial agent as well as its chief engineer. The demands of his several roles kept Eads constantly shuttling back and forth between St. Louis, the brokerage houses of New York and London, and the steel mills of Philadelphia and Pittsburgh. No one else could joke with unlettered rivermen one day, solve complex engineering problems the next, and a few days later leave for Europe to negotiate a bond sale. Eads moved easily in the heady atmosphere of international investment capitalism, where millions might change hands during a gentlemanly conversation over fine sherry and good cigars. He won the friendship of financier Junius Morgan (J. P. Morgan's father), and even the grudging admiration of Andrew Carnegie, who otherwise found him picky and obstinate. Years later, Eads's old river crony Emerson Gould would insist that however impressive Eads's engineering accomplishments might have been, his real talent was his ability to manipulate money and men.[44]

Although work on the foundations and the superstructure overlapped somewhat in time, the actual construction of the bridge divided naturally into two phases, each with its own peculiar problems. The challenge of the piers and abutments is as simple to state as it was difficult to meet: they had to rest on the bedrock. Sinking the west abutment had been relatively easy, for at that point the rock was near the surface. An open-ended cofferdam held seepage and sediment back while masons laid the foundation stones.

Sinking the river piers and the east abutment required considerably more technical ingenuity. At first, Eads planned to use cofferdams once again. Like an enormous open tube suspended vertically over the site of a pier, the iron and timber cofferdam would be held in place by huge threaded rods anchored to pilings. Turning the giant screws lowered the cofferdam to the riverbed. As steam scoops and bucket conveyors removed the sand from within the cofferdam, it would be lowered until it reached the bedrock. There would be no attempt to make the cofferdam watertight; its purpose was merely to hold back the sand. Once the bedrock was exposed, Eads proposed to float a platform inside the cofferdam and lay the masonry pier on top of it. The accumulating weight of the stone would slowly sink

44. Gould, *Fifty Years on the Mississippi*, pp. 486–88; Joseph F. Wall, *Andrew Carnegie* (New York, 1970), pp. 267–81.

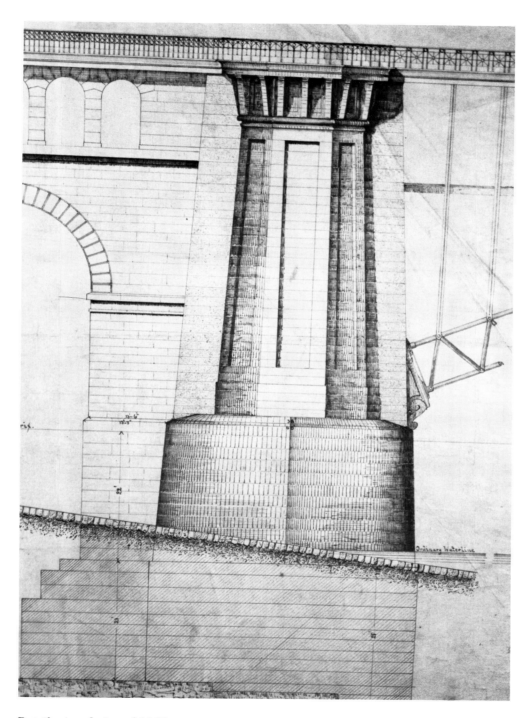

Detail, pier, design of 1868.

the platform to the bedrock. With luck, Eads might be able to recover the cofferdam and use it again.[45]

During his European trip of 1868–1869, Eads discussed his plans with leading French and British engineers and observed at firsthand the relatively new and uncertain *plenum pneumatic* method for sinking subaqueous foundations. Instead of an open-ended cofferdam, the pneumatic method employed a caisson sunk to the riverbed. The caisson was watertight and terminated in an air chamber under an airtight and strongly braced bulkhead. In effect, the bottom of the caisson became a diving bell, an oversized and more sophisticated version of Eads's old salvage device. Compressed air forced into the chamber kept the water out and supplied oxygen for the workmen, while air locks permitted them to come and go without affecting the air pressure inside. The workmen (or "submarines," the current name for sandhogs) shoveled the sand into pumps that carried it upward through pipes and discharged it into the river. As the caisson sank, its sides were built up and caulked so that it always remained watertight, its top well above river level. Masons, working comfortably in the open air, laid the masonry pier on the top of the bulkhead that served as the roof of the air chamber, leaving a hollow core for stairwells, elevators, and piping. As the masonry rose, the caisson sank to the bedrock, its rate of descent controlled by the rate of excavation and by the buoyancy of the air in the chamber. Once the caisson reached bedrock the submarines would retreat up the core, filling the air chamber and the shaft behind them with concrete. The end product was a solid masonry and concrete foundation wedded to the bedrock.[46]

In principle the scheme was simple enough. In application it required elaborate and specially designed equipment, considerable skill at organizing material and men, and incredible luck. Eads had to build a V-shaped breakwater of pilings and timbers upstream to fend off floating logs, ice, and wayward steamboats. He sank ten huge pilings to guide the caisson until it was seated securely in the sediment of the riverbed. Eads built a

45. Eads, *Addresses and Papers*, pp. 501–4.
46. Ibid., pp. 64–77, 540–48; Milnor Roberts, "Description of the 'Plenum Pneumatic Process' as Applied in Founding the Piers of the Illinois and St. Louis Bridge, at St. Louis, Mo.," *Transactions of the American Society of Civil Engineers* 1 (1872):259–73; William Sooy Smith, "Pneumatic Foundations," *Transactions of the American Society of Civil Engineers* 2 (1872–1874):411–26.

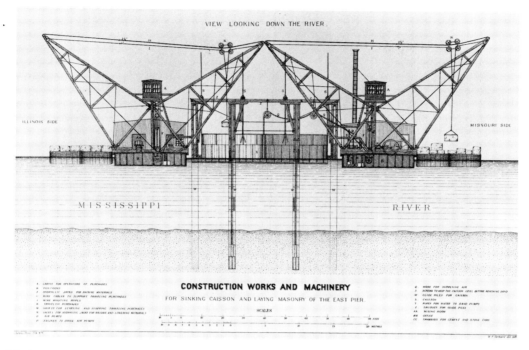

Machinery for sinking the east pier, 1869.

pair of 215-foot workboats to flank each caisson and serve as floating platforms for boilers, engines, and pumps and for the elaborate, derricklike "travelers" that maneuvered the seven-ton stone blocks into place.

Given the difficulties and dangers inherent in the undertaking, the sinking of the river piers went fairly smoothly. Eads laid the first stone of the east pier in October 1869 and the first stone of the west pier the following January. When the weather and the river permitted, Eads's crew worked round-the-clock during the next few months laying forty thousand tons of stone and concrete. By May, the river piers were completed above the waterline. Construction of the towers waited on the installation of the arch anchor bolts.

Eads's novel air chamber became a tourist attraction. Hundreds of well-dressed ladies and gentlemen descended the long spiral staircases to visit the submarines at work. By all accounts it was scary. Under atmos-

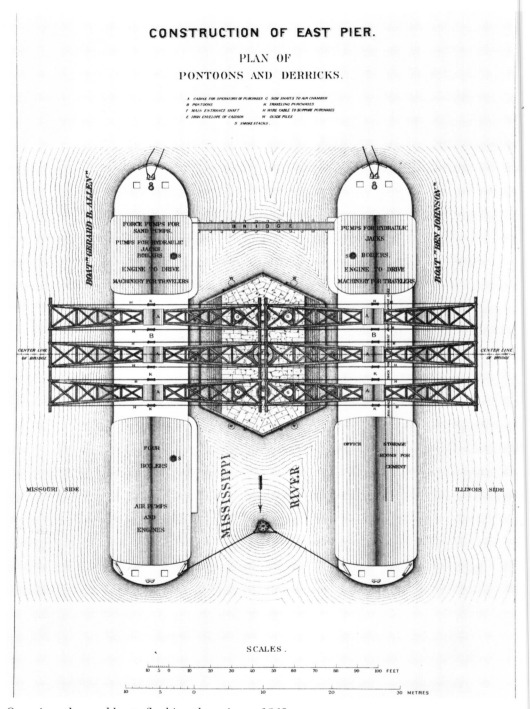

Overview, the workboats flanking the caisson, 1869.

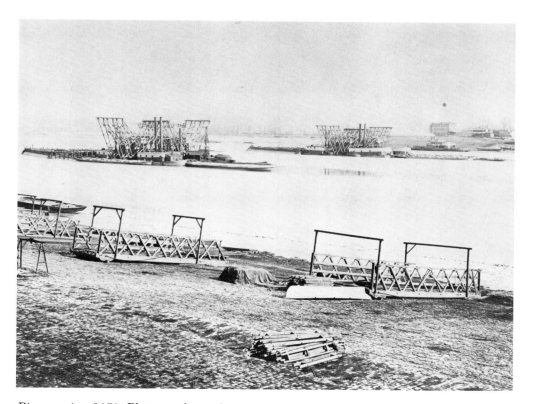

Piers, spring 1870. Photographer unknown.

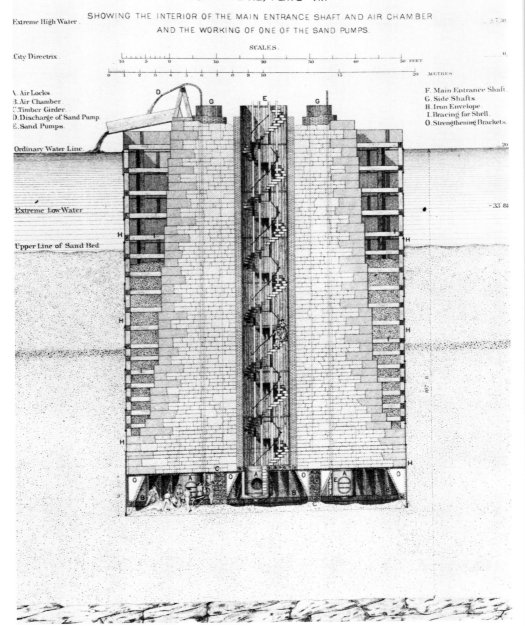

Cross section, the east pier caisson.

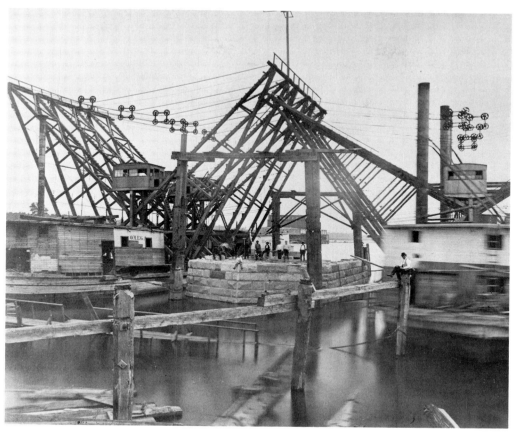
Sinking the east pier, spring 1870. Photographer unknown.

pheric pressures nearly three times normal, candles burned peculiarly and voices assumed an eerie timbre. "The air had such a strange density and moisture," reported a local publicist, "that one wandered about almost as if he were in a dream." For a few minutes it was exhilarating. Then the novelty wore off and the terror crept in. "Gladly did the visitor, after a quarter of an hour, re-enter the air-lock, with an unfeigned feeling of relief." After a few minutes of decompression in the air lock, the tourists escaped into the open air.[47]

The submarines were less fortunate; for some of them the air chamber became a death trap. A few minutes in the air lock was far too short a time to be safe from the "bends," or caisson disease, an excruciating and potentially fatal malady caused by dissolved nitrogen forming bubbles in the bloodstream during too-rapid decompression. After two hours of work at one hundred feet, the submarines should have undergone gradual decompression for at least two hours and thirteen minutes. Instead, they rarely spent more than five minutes in the air lock. The decompression rate was subject to the whim of the lock tender and to the desires of the men, who preferred to reach the surface as quickly as possible after quitting time. No one had ever worked for such long periods at such high pressures, and there were no convenient and authoritative U.S. Navy decompression tables to inform Eads of the physiological hazards involved. Initially, he took the bends lightly. He had been diving for years without ill effects (he attributed his own chronic debility to other causes and seemed not to see any connection between caisson work and Charles Pfeifer's rapidly deteriorating health). Eads insisted that the bends resulted from excessive working time in the caisson and, even more, from too many off-hours in riverfront saloons. The notion that disease was a punishment for moral transgression was a common Victorian conceit; Eads noted that temperate submarines rarely succumbed. The workmen themselves dealt with the bends by continuing to drink and tried to ward off the cramps with patent medicines and electromagnetic amulets. More to the point, in March 1870 the men struck for shorter hours and higher pay. Previously, submarines had worked three watches of two hours each for four dollars per day. Now they de-

47. Logan Reavis, *History of the Illinois and St. Louis Bridge* (St. Louis, 1874), pp. 10–11; Eads, *Addresses and Papers*, pp. 559–63.

manded five dollars per day for two watches of two hours. Eads held firm; the strike collapsed after four days.

Soon thereafter, the first submarine died. Eads immediately cut the length and number of watches per day and directed his family physician, Dr. Alphonse Jaminet, to oversee the health of the men. Jaminet set up a floating hospital next to the caisson and began a systematic study of the bends. He concluded that the compression and decompression rates were critical, though like most contemporary experts he assumed that the former was more significant than the latter. His rule-of-thumb decompression formula, one minute of time for each six pounds of pressure, was still far short of the modern guidelines, but it was a decided improvement over previous practice. Together, Eads and Jaminet did a number of the right things (even if for the wrong reasons) and materially reduced the incidence of caisson disease. Jaminet's research also helped lay the foundation for modern diving physiology. The costs of underwater pioneering had been high, however; although in retrospect it is astounding that they were not even higher. Of the 600 submarines who worked on the caissons, 119 were stricken. Fourteen died.[48]

The successful sinking of the river piers demonstrated that it would be possible to foot the east abutment on bedrock. Eads previously had assumed that the great depth of the rock, 127 feet below the Directrix, would make it impossible to reach. Yet that was a mere eight feet deeper than the successful east pier. The sheer scale of the new plan was awesome. Sunk to the bedrock, the east abutment would require more masonry belowground than the west pier had in its entirety. It would tower 197 feet from the bedrock to the top of the cornice. It would also cost $175,000 more than his original estimate. Yet that seemed a small price to pay for "terminating forever all doubts as to the absolute stability of each one of the four great piers."[49]

48. Alphonse Jaminet, *Physical Effects of Compressed Air, and of the Causes of Pathological Symptoms Produced on Man, by Increased Atmospheric Pressure Employed for the Sinking of Piers, in the Construction of the Illinois and St. Louis Bridge over the Mississippi River at St. Louis, Missouri* (St. Louis, 1871), pp. 11, 41–42, 101–7, 116–17; Eads, *Addresses and Papers*, pp. 559–63; Woodward, *History of the St. Louis Bridge*, pp. 245–63. U.S. Navy, *U.S. Navy Diving Manual* (Washington, D.C., 1970), pp. 79–85, 110–13.
49. Eads, *Addresses and Papers*, p. 565.

Redesigned in the light of his experience with the river piers and launched in November 1870, the east abutment caisson sank easily to bedrock. In spite of interruptions due to floods and ice floes and a spring tornado, within six months the abutment had been completed up to the level of the anchor bolts. The first and most difficult phase of construction was finished, although the product—four squat blocks of masonry lined up across the river at five-hundred-foot intervals—did not seem very dramatic to the casual observer.

Eads nevertheless had good reason to be proud of his accomplishment. His deep caisson work marked a new chapter in the annals of civil engineering. He had delivered all that he had promised, justifying his engineer's faith by tangible works. The east abutment was his masterpiece. "When I left it to-day," he had written soon after the caisson had reached the riverbed, "I could not help being impressed with the feeling that I had never undertaken any mechanical or engineering performance before with such full assurance that failure was absolutely impossible as in the case of this, the greatest work of my life.... I cannot believe anything can possibly occur that would prevent my assistants from safely placing the monster mass of masonry exactly where I intend it to rest, even if I were stricken out of existence to-morrow."[50]

At that moment, Eads was considerably less optimistic about the superstructure. The Keystone Bridge Company had had the construction contract for months, yet there were no signs of progress on the riverfront. Relations with Keystone had in fact deteriorated as mounting exasperation on one side met mounting frustration on the other. Some of the misunderstandings were probably inevitable. Eads had underestimated the difficulty of building a steel bridge in an iron age. Some of his metallurgical requirements were simply beyond the capacity of current technology. His elaborate and exacting demands for close quality control made other specifications difficult to meet. It was not merely that the design was unusual, or that he had specified steel for certain structural members, or that he had an understandable desire to insure that his bridge was well built. Eads intended the superstructure to be as much of an engineering showpiece as were the abutments and piers. His insistence on exactitude sometimes went

50. Woodward, *History of the St. Louis Bridge*, pp. 63–64.

as far beyond practical necessity as it did beyond current industrial practice.

Perfectionism for its own sake annoyed Keystone executives Jacob Linville and Andrew Carnegie. Linville still had his doubts about the entire enterprise and favored his own patent truss design. Carnegie was more sanguine, but he had a financial as well as a technical interest in the bridge; he had become a principal stockholder and was earning substantial commissions selling bridge bonds abroad. Extra precision cost extra money; and, under the current contract, Keystone had to cover the added expense. "Nothing that would please and that does please other engineers is good enough," protested Carnegie. "This Bridge is one of a hundred to the Keystone Company—to Eads it is the grand work of a distinguished life. With all the pride of a mother for her first-born, he would bedeck the darling without much regard to his own or others' cost All right says Keystone, provided he allows the extra cost and the extra time."

Carnegie was probably less interested in cost overruns than he was in curbing Eads's urge to innovate. He had used his position at Keystone to award the subcontract for all the bridge ironwork to his own firm, Carnegie Kloman. As the nation's leading ironmaster, he was less than enthusiastic over Eads's determination to use substantial amounts of steel, particularly since Keystone had to buy the steel from rival firms. Carnegie also resented Eads's noisy claims that regular Pittsburgh shop practice was not good enough for the St. Louis bridge. "Capt. Eads must only require the custom of the trade," he pleaded. "You must keep Eads up to requiring only what is reasonable and *in accordance with custom*."[51]

The custom of the trade often substituted overbuilding for close analysis, and on-site adjustments for accurate fabrication in the shop. Scientific quality control had not replaced easygoing metallurgy. Forty years later, even Carnegie would admit that the industry had been foolish to so long ignore chemistry and physics, but in the 1870s "rule-of-thumb-and-intuition" still dominated the mills. Anyone who asked for more was asking for trouble.[52]

51. Theodore Cooper, "The Use of Steel for Bridges," *Transactions of the American Society of Civil Engineers* 8 (1879):263–74; Woodward, *History of the St. Louis Bridge*, pp. 71–72.

52. Eads, *Addresses and Papers*, pp. 547–78; Chester H. Gibbons, *Materials Testing Machines* (Pittsburgh, 1935), pp. 34–37. Eads's specifications for steel and

Eads violated the custom of the trade at every turn. His specifications were unusually precise. His testing machine, designed by Henry Flad, detected stress deformations as small as 1/200,000 of an inch. Inspectors armed with templates and gauges prowled the subcontractors' shops under orders to reject anything showing the "least imperfection." Holes were to be accurately drilled, not punched in the usual manner ("a thing unheard of!," muttered Carnegie). Eads generally insisted on testing individual members. When he did permit the testing of random samples, even a low failure rate was sufficient to reject the whole lot. Given Eads's expectations and Keystone's capabilities, it was hardly surprising that delays lengthened from weeks into months. Nor was it surprising that the finished structure contained less steel and more iron than Eads had intended.[53]

The anchor bolts were the first in a series of metallurgical frustrations. Each rib terminated in a wrought-iron skewback plate, which in turn was

ironwork, as reported in Eads, *Chief Engineer's Report, 1870*, appendix, and in Woodward, *History of the St. Louis Bridge*, pp. 72–76, were as follows:

Member	Tensile Limit of Elasticity[1]	Ultimate Tensile Strength[1]
Cast bed plates (cast iron)	20,000	
Anchor bolts (wrought iron)	20,000[2]	60,000
Anchor bolts (steel)	40,000	100,000
Skewback plates (wrought iron)		60,000
Tube staves (steel)[3]	40,000	90,000
Tube envelopes (steel)	40,000	90,000
Tube couplings (wrought iron)	40,000	90,000
Pins (steel)	40,000	100,000
Main braces (wrought iron)	20,000	60,000
Eye plate washers (steel)		100,000
Tension rods between ribs (wrought iron)	40,000	100,000
Horizontal stays between ribs (wrought iron)[4]	40,000	100,000
Diagonal braces between main braces (wrought iron)	18,000	50,000
Plate beams (wrought iron)		60,000
Angle beams (wrought iron)		50,000
Suspension bars (wrought iron)	15,000	60,000
Vertical struts (wrought iron)	18,000	50,000
Tension rods (wrought iron)	20,000	60,000
Wind-truss and upper-roadway bracing (wrought iron)	55,000	
Wind-truss anchor bolts (wrought iron)	20,000[2]	60,000

1. In pounds per square inch. 2. Later changed to 18,000.
3. Modulus of elasticity, 26,000,000 to 30,000,000 pounds per square inch.
4. Compressive limit, 15,000 pounds per square inch.

53. Eads, *Chief Engineer's Report, 1870*, appendix; Eads, *Addresses and Papers*, pp. 574–76; Woodward, *History of the St. Louis Bridge*, pp. 72–78; Gibbons, *Materials Testing Machines*, pp. 34–37.

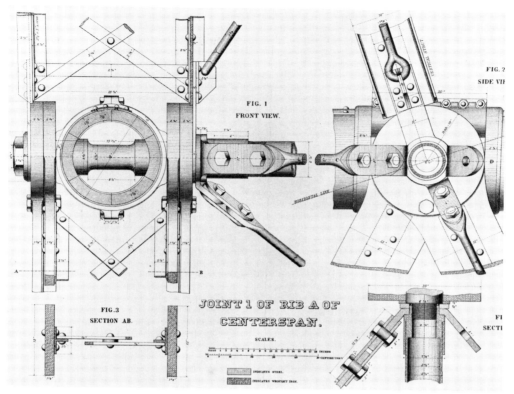

Detail, rib joint.

fastened to the pier by anchor bolts sunk deep into the masonry. Eads ordered carbon steel for the eighty lower bolts and less-costly wrought iron for the thirty-two upper bolts, which were subjected to less strain. Iron would in fact have served perfectly well for all, but Eads was determined to provide an added margin of safety. The iron bolts, forged by Carnegie Kloman, easily passed Eads's mechanical tests. But the carbon-steel bolts, manufactured by the William Butcher Steel Company of Philadelphia, ruptured far short of the required tensile strength, damaging the testing machine and maiming several workmen in the process. Inconsistencies in composition and improper methods of forging and heat-treating the metal probably accounted for their failure. Structural steel, confessed Linville, was at best "still experimental."[54] With the bridge now six months behind schedule, Eads turned in desperation to chrome steel, an exotic alloy whose secret

54. Woodward, *History of the St. Louis Bridge*, pp. 78–84.

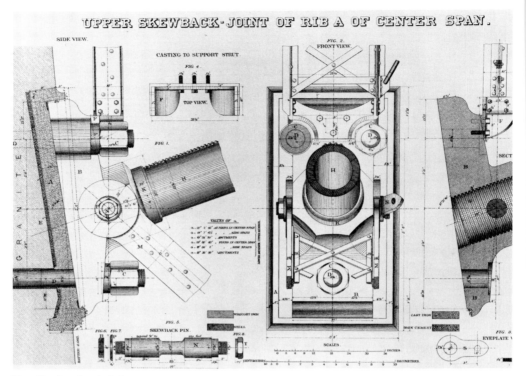

Detail, skewback joint.

formula was guarded by patent. It proved considerably easier to work. Even so, Eads came out twenty-one bolts short and had to settle for the remainder in wrought iron.

Chrome steel also solved the problem of the great arch ribs. Each twelve-foot section was built like a barrel, with six steel staves bound together within a thin sheet-steel envelope. Component parts had to be closely matched in strength and in their modulus of elasticity; the necessary rolling-mill machinery had to be built for the job; machining tolerances were unusually close. William Butcher's steelmakers and Keystone's machinists worked six months to produce a single carbon-steel stave suitable for testing. It failed. Once again, Eads turned to chrome steel. A hundred experimental staves came from the mill "all beautifully and perfectly rolled," convincing Eads that his metallurgical problems were behind him. In Octo-

ber 1871 he confidently announced that erection of the superstructure would soon begin.[55]

Confusing enough at the time, the story of Eads's decision to use chrome steel has grown even more confusing since. Histories of engineering regularly cite Eads Bridge as the world's first chrome-steel structure and credit Eads with the first major application of any kind of structural alloy steel. He appears as a bold innovator whose foresight helped usher in the modern age of steel-frame construction. Such accounts are not so much mistaken as they are misleading; they explain too little by claiming too much. Historians read human experience backwards, using hindsight to show a more or less orderly and intentional progression from decision to consequence, cause to effect. But history read frontwards, the way it was lived, is likely to display a far messier, but more human, picture of false starts and blind alleys, of progress through accident and success through blunder and luck. James Eads was a metallurgical pioneer by default. Chrome steel was his second choice, an unknown material that looked promising only after carbon steel had made such a poor showing. Although later generations would regard his use of chrome steel as an engineering milestone, the most innovative aspect of the entire project, Eads did not. Nor were his contemporaries particularly impressed; they generally ignored his achievement entirely, dismissed it as an engineering quirk, or questioned whether Eads had actually used chrome steel at all.

"WARRANTED SUPERIOR TO ANY STEEL IN THE MARKET—EITHER ENGLISH OR AMERICAN—FOR EVERY PURPOSE." So ran the ads of the Chrome Steel Company of Brooklyn, New York. It was uncertain how and when

55. Eads, *Addresses and Papers*, p. 593. According to test results reported in Woodward, *History of the St. Louis Bridge*, pp. 302–13, William Butcher's chrome steel showed wide variations:

Tensile Strength	*Compressive Strength*	*Modulus of Elasticity*
Low 64,290	Low 35,700	Low 8,506,000
High 151,000	High 68,700	High 50,000,000
Average 107,683	Average 57,447	Average 17,681,000

Compare Butcher's product with samples of Chrome Steel Company steel tested in 1869 by David Kirkaldy in England, as reported in *Iron* 9 (7 April 1877):428, and Woodward, *History of the St. Louis Bridge*, pp. 305, 313:

Tensile Strength	*Compressive Strength*
Low 49,000	Low 69,000
High 106,000	High 106,000
Average 81,500	Average 86,563

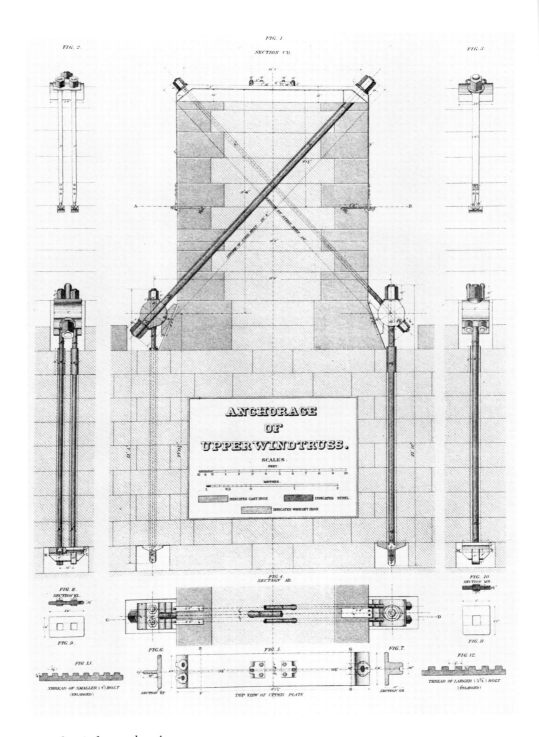

Detail, wind-truss bracing.

Eads first learned of chrome steel, but it was clear that most of what he understood about the alloy came from the company's advertising circulars. A new firm, founded in 1868, the Chrome Steel Company manufactured specialty steels for tools and burglarproof safes under a process patented in 1865 by Julius Baur, a New York metallurgist. Baur believed that he had discovered a way to substitute the metal chromium for the carbon in ordinary steel. He claimed that this new metal, "similar to steel," was harder, tougher, yet more uniform and more easily worked than the carbon steel of commerce.[56]

Baur was doubly mistaken. He had not "discovered" anything, but had merely secured a patent on a process reported by British and French chemists in the 1820s.[57] Moreover, he fundamentally misunderstood the chemistry of his own product; chromium did not take the place of carbon. It did alloy with the iron-carbon compound commonly called steel, and in high concentrations it did add significantly to its hardness and corrosion resistance. But, while carbon was essential to steel, chromium was not. Indeed, Baur's alloys owed their characteristics far more to their carbon content than to the relatively low amount of chrome they contained.

The Chrome Steel Company deliberately cloaked its product with an aura of mystery. The basic ingredients were simply high-grade wrought iron and chrome ore, mixed and melted in graphite crucibles. But the critical element was a secret powder, added dramatically just before the melt was poured. Baur's mystery ingredient was probably charcoal, perhaps mixed with a fluxing agent. Charcoal would have accounted for the steel's carbon content. On the other hand, the secret ingredient may have been some inert substance that contributed nothing to the steel beyond good advertising copy.[58]

56. *Iron Age* 1 (11 January 1872):5; U.S. Patent no. 49,495, issued 22 August 1867; *Scientific American* 13 (2 September 1865):152; "Chrome Steel Works," in *Half-Century's Progress of the City of Brooklyn* (New York, 1886), p. 127; *Iron* 9 (27 January 1877):103; Henry M. Howe, *The Metallurgy of Steel* (New York, 1894), pp. 75–80.

57. M. Boussingault, "Sur la production, la constitution et les propriétés des aciers chromés," *Annales de chimie et de physique* 5, no. 15 (1878):91–126.

58. For accounts of the Chrome Steel Company process, see "Chromstahl von The Chrome Steel Works in Brooklyn, N.Y.," *Stahl und Eisen* 2 (April 1882):165; "Chrome Steel," *Van Nostrand's Engineering Magazine* 4 (April 1871):376–78; H. S. Osborn, *The Metallurgy of Iron and Steel* (Philadelphia, 1869), pp. 132–33. For modern dis-

A number of Gilded Age metallurgists were justly suspicious of the company's cryptic methods and extravagant claims, but not so James Eads. He accepted their chemical misrepresentations at face value and passed them on as scientific facts in his annual reports as chief engineer. Eads paid the Chrome Steel Company a fifteen-thousand-dollar royalty to allow William Butcher to manufacture chrome steel for the bridge. In the fall of 1869 he sent Henry Flad to Brooklyn to learn the details of the arcane process.[59]

Because of contract obligations to Keystone, Eads could not demand the use of Baur's particular alloy; the Chrome Steel Company's patent would have prevented Keystone from seeking competitive bids from other firms. Instead, he left the question of chemical composition open and merely specified mechanical requirements. "These conditions being fulfilled by the steel-maker," he wrote, "I am indifferent as to whether he furnishes carbon or chrome steel for the tubes, just as I would be in receiving iron for the Bridge; if it fulfilled the specifications, I should not deem it important to know whether it was Sligo, Lowmore, or Swedish."[60]

In effect, Eads's chemical carte blanche permitted the steelmakers to deliver anything, so long as it passed his mechanical tests. Apparently the steelmakers did just that. Mixtures varied wildly as William Butcher, who kept no records, continually tinkered with Julius Baur's recipe. After 1872, when William Durfee replaced Butcher as superintendent and the firm was reorganized as the Midvale Steel Company, chrome steel was apparently abandoned altogether. Eads believed that all the staves were chrome steel. Yet, short of analyzing samples from each of the 6216 staves—a practical impossibility—there was no way to know just how much of the "world's first chrome steel structure" was actually chrome steel. Opinions varied. Henry Howe, the nation's leading metallurgist in the 1880s, concluded after careful study that Eads had been hoodwinked: "The contractors . . . were at liberty to supply either carbon or chrome steel. Actually they supplied

cussions of chrome steel see Richard H. Greaves, *Chromium Steels* (London, 1935); Leslie Aitchison, *A History of Metals*, 2 vols. (New York, 1960); and A. H. Sully and E. A. Brandes, *Chromium* (New York, 1967).

59. Eads, *Addresses and Papers*, pp. 590–94; Woodward, *History of the St. Louis Bridge*, pp. 82–87; Howe, *Metallurgy of Steel*, pp. 79–80.

60. Eads, *Addresses and Papers*, p. 593; Woodward, *History of the St. Louis Bridge*, pp. 116–18.

chromeless steel, which was accepted. Eads had evidently been completely deceived."[61] Twentieth-century tests, however, showed that Howe, too, had been lead astray by a sampling error. Some of the staves, at least, were composed of unusually high-grade chrome alloy steel.[62]

Eads's ironwork proved hardly less problematic than the steel. The main braces, heavy wrought-iron bars that zigzagged between the upper and lower ribs, were critical to the structural integrity of the arch. Throughout the summer and fall of 1871, Carnegie Kloman fabricated dozens of sample braces, only to have Eads's inspectors reject them for structural flaws or insufficient strength. Keystone protested that the testing methods were too stringent. Eads replied with accusations of shoddy workmanship and

61. *1942: The Seventy-Fifth Anniversary of the Midvale Company* (Nicetown, Pa., 1942), pp. 11–16; Howe, *Metallurgy of Steel*, pp. 79–80. Howe first published his exposé in *Engineering and Mining Journal* 44 (1 October 1887):242–43. His claim went unchallenged and appeared unaltered in all subsequent editions of *Metallurgy of Steel*.

62. E. E. Thum, "Alloy Bridge Steel Sixty Years Old," *Iron Age* 122 (20 September 1928):683–86, 733–34, reported the following analysis of borings taken from the arch tubes:

	Low (%)	*High (%)*	*Average (%)*
Carbon	.64	.95	.79
Manganese	.018	.23	.11
Silicon	.156	.19	.10
Sulphur	.006	.013	.009
Phosphorus	.007	.082	.044
Chromium	.54	.68	.61

In 1973 a barge collision damaged a rib section in the east span. The section was removed and is now displayed at the National Museum of Transport, St. Louis, Mo. In June 1978, Dr. John Roberts and Joseph Vollmar, Jr., graciously made samples from this tube available for testing. These analyses, made through the courtesy of R. C. Solomon, vice-president—quality control, Granite City Steel Division, National Steel Corporation, Granite City, Ill., revealed the following composition:

	Low (%)	*High (%)*	*Average (%)*
Carbon	.476	.829	.641
Manganese	.10	.21	.183
Silicon	.05	.16	.102
Sulphur	.010	.028	.022
Phosphorus	.076	.166	.120
Chromium	.33	.61	.453
Copper	.035	.075	.062
Nitrogen	.003	.007	.006
Oxygen	.0095	.0651	.0412

For a more elaborate discussion of the chrome-steel question, see my forthcoming article, "The Case of the Chromeless Chrome Steel Bridge: Artifact Versus Document in the History of Technology."

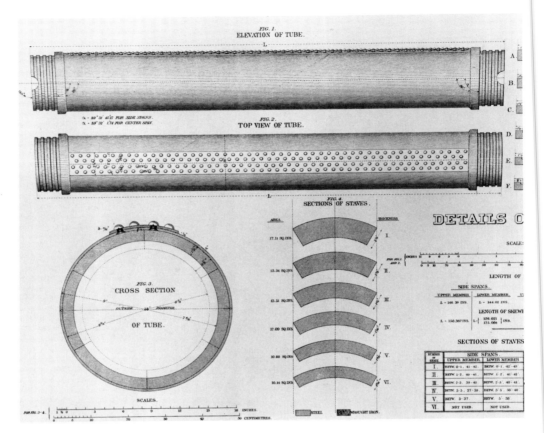

Detail, tubes.

threatened to embarrass the iron industry by substituting chrome steel instead. A mutually unsatisfactory compromise was reached in December 1871 when Eads lowered his tensile-strength requirements and Carnegie Kloman gave more attention to quality control. It would still be six more months, however, before acceptable main braces arrived in St. Louis.

Discouraging delays and rumors of incipient failure had brought bridge affairs to the point of crisis. Stockholders were restive. Carnegie was furious. At the December 1871 corporate meeting he pushed through a resolution calling for an outside consulting engineer to oversee Eads's work. Whatever private annoyance or anxiety Eads might have felt over this adverse vote, his public stance remained cool and confident. When the consultant, James Laurie, questioned the ultimate strength of the assembled rib sec-

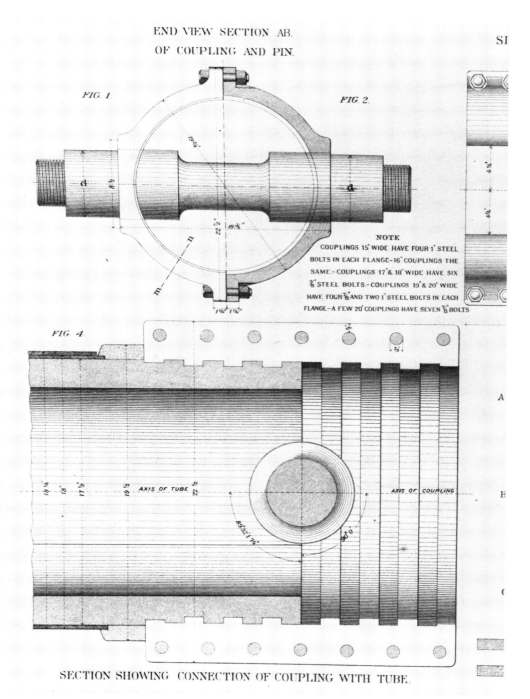

Detail, couplings.

tions, Eads replied that each tube would withstand a compressive load of 11.7 million pounds and offered to prove it by wedging a tube and a hydraulic ram between the unyielding walls of a stone quarry and crushing the tube to destruction. Apparently reassured by Eads's almost defiant stance, Laurie backed down. His final report vindicated Eads in all but a few minor details.[63]

All that now stood between Eads and success were 1012 sleeve couplings. They turned out to be the worst metallurgical nightmare of all. The couplings were formed in half-sections, with grooves machined on the inside to match annular grooves cut on the ends of each rib section. Bolted around each rib joint, they united the sections into a continuous arch and also formed the junction point for a complex intersection of main and wind-truss bracing. They had to be precisely made, uniform, and strong. Eads's specifications called for steel. Keystone and a succession of subcontractors tried for two full years to produce the couplings. Cast couplings were honeycombed with bubbles. Forged couplings developed internal flaws under the hammer. Neither behaved predictably during heat treatment. Chrome couplings were hardly better than those of carbon steel. Finally, in March 1873 Eads was forced to admit that the best American steelmakers had to offer was not good enough; and he retreated to the softer but more malleable wrought iron. Indeed, Eads's celebrated "steel" bridge would in reality be more than half wrought iron. If he had won a partial

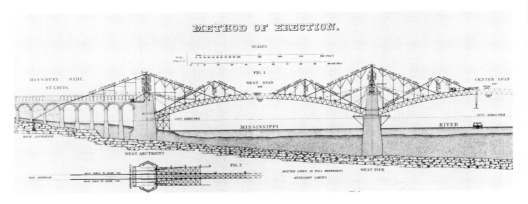

Cross section, temporary supports for the arches during construction.

63. Woodward, *History of the St. Louis Bridge*, pp. 85–90, 106–8, 116–19.

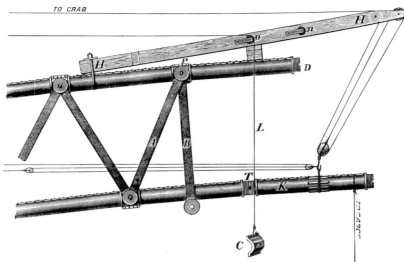

Fig. 28.—METHOD OF ERECTING A RIB.

Detail, rigging used in erecting the rib sections.

victory for alloy steel, the custom of the trade had only suffered a partial defeat.

During the long months of waiting, Henry Flad had devised a scheme for erecting the arches. Normally such a bridge would have been erected with falseworks, temporary scaffolding built up from the riverbed to support the bridge until it could support itself. Falseworks were impossible in this case, since the rivermen would not tolerate such an obstacle to free navigation. Moreover, any upstream freshet might suddenly sweep away the falseworks and send the unfinished superstructure plunging into the river. Since the bridge could not be supported from below, it would have to be suspended from above. Flad set temporary wooden towers atop the piers and abutments to support adjustable rigging that would hold the rib sections in place as they were bolted together end to end. As the arches extended outward from the piers, supplementary towers would be placed on the arches themselves, with supporting cables attached at every third rib joint. When the cantilevered half-spans met at midstream, a final "keystone" rib section would join them into a single, self-supporting arch. Work could

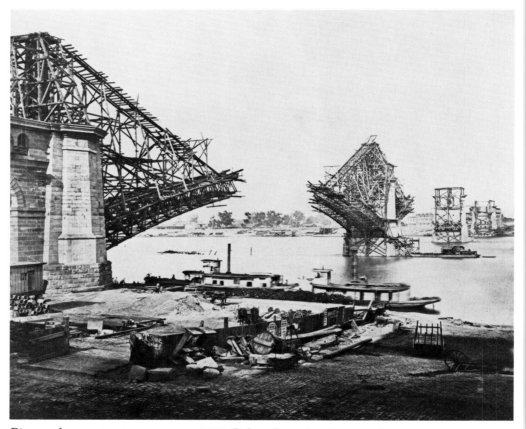

Piers and superstructure, summer 1873. Robert Benecke, photographer.

proceed at any river stage. Steamboat traffic would not be interrupted at all.[64]

Like most other aspects of the project, the scheme for erecting the superstructure was as simple in conception as it was complex in application. It was theoretically possible to mate the two half-spans in midair, but only if the original calculations had been correct and only if the bridge as built conformed to the bridge as planned. Neither proved to be the case. Eads had estimated that the weight of the span would compress its own length by 3.252 inches, and he had increased the overall length of the arches accordingly. The assembled chrome-steel ribs turned out to have a higher modulus of elasticity than he expected, however; the first arch shrank only

64. Walter Katte, "A Description of the Proposed Plan for Erecting the Superstructure of the Illinois and St. Louis Bridge," *Transactions of the American Society of Civil Engineers* 2 (1873): 135–44.

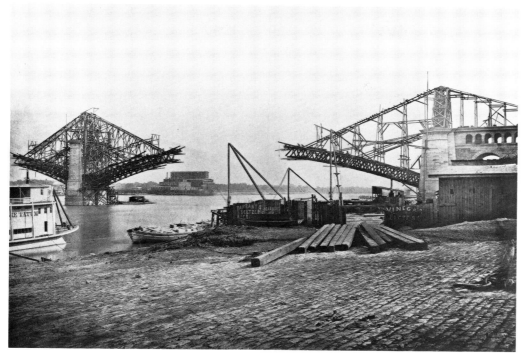
North side of west span, late summer 1873. Robert Benecke, photographer.

2.256 inches. The placement of the piers was also slightly off, so that the distance between the skewbacks varied three-eighths to three-quarters of an inch from the specifications. The errors were miniscule compared to the massive scale of the bridge, but a miscalculation of even an inch could mean failure. It was possible, within narrow limits, to spring the arches apart by increasing the tension on the supporting cables. It might also be possible to take advantage of thermal expansion and contraction, for a span in the cool of the morning might be as much as two inches shorter than it would be in the heat of the afternoon. But these were empirical questions; they could not be answered with certainty in advance.[65]

On 7 April 1873 Flad installed the first three sections of the inner pair of ribs on the west abutment and the west pier. Work then stopped for a month for want of sleeve couplings and other materials. Eads, impatient

65. Theodore Cooper, "The Erection of the Illinois and St. Louis Bridge," *Transactions of the American Society of Civil Engineers* 3 (1875):239–54.

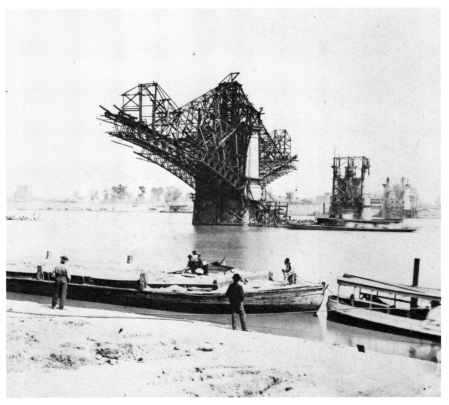
West pier, fall 1873. Boehl and Koenig, photographers.

to be finished and anxious to reassure skittish investors, urged Keystone to hurry. Linville, increasingly fearful that the arch could not be closed, dragged his heels in the hope that a new contract would transfer responsibility for the potential failure from Keystone to the bridge company itself. In August, a new contract provided Keystone with added economic incentives, and the pace quickened at the construction site.

The strain was too much for James Eads. His health failed again, the chronic coughing now complicated by hemorrhaging lungs. Henry Flad and Theodore Cooper, back from his previous assignment as chief inspector at the steel mills, took charge. Late in August, Eads took a formal leave of absence and left for Europe.

He had hardly sailed before a new crisis appeared from an unexpected quarter. Mississippi steamboatmen had been watching with mounting an-

noyance as the great arches slowly advanced over the channel. Always critical of river piers, they now feared that their tall smokestacks and pilothouses might not clear the arches during high water. Although practically unnecessary, the towering stacks and texas decks, flamboyant in their gaudy paint and gilded fretwork, were the boatmen's pride, cherished trademarks of the western steamers. Hinging the stacks or trimming down the decks was unthinkable. The boatmen complained to Secretary of War William Belknap, who obligingly ordered the U.S. Army Corps of Engineers to determine whether the bridge was a serious obstacle to navigation.

The corps had its own reasons for attacking James Eads. He and the chief engineer, Gen. A. A. Humphreys, had been at odds for years. Part of their animosity was fueled by the general rivalry between civilian and military engineers in nineteenth-century America. More of it had to do with their opposing theories of river hydraulics, their debates over the proper methods for dredging the mouth of the Mississippi, and their mutual tendency to call each other fools in public.

Born in a cynical alliance of selfish interests, the board of inquiry set to work proving its foregone conclusions. It solicited testimony from hostile boatmen, but refused to hear witnesses on behalf of the bridge. Early in September the board issued its report, which General Humphreys approved and forwarded to the secretary of war. It condemned arch bridges in general and the St. Louis bridge in particular. It recommended either bypassing the bridge with a deep-water canal on the Illinois shore or dismantling the bridge altogether![66]

Flabbergasted, Eads hurried home from Europe and drafted a searing rebuttal exposing the erroneous and biased report. A canal, he wrote, would be impractical and ruinously expensive. It would destroy the East St. Louis wharf and seriously interfere with rail traffic. Above all, it would "mutilate the Bridge." Eads understood perfectly well that it would require more than public opinion to overcome the combined political influence of boatmen, army engineers, and an easily bribed secretary of war (Belknap would be impeached in 1876). He appealed directly to his old friend President Grant, who still owed Eads favors from the gunboat days during the Civil War. Grant listened attentively as Eads explained his prob-

66. *Engineering and Mining Journal* 16 (11 November 1873):313; Woodward, *History of the St. Louis Bridge*, pp. 263–83.

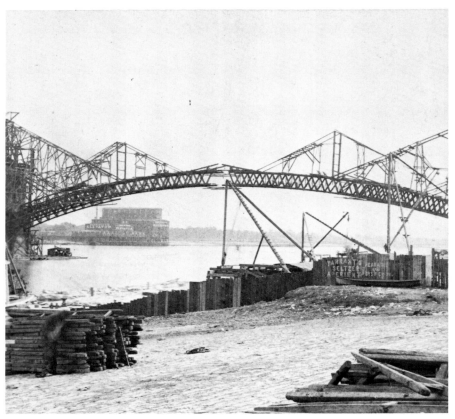
Closing the west span, September 1873. Robert Benecke, photographer.

lem. He then called in Secretary of War Belknap and said, "I think General, you had better drop the case." Red-faced, Belknap agreed and backed hastily out of the presidential office. The Corps of Engineers shelved the report.[67]

Ignoring the political storm swirling around them, Flad and Cooper had gone ahead and closed the arch. Their task was to fit a last and slightly oversized piece into a rigid and slightly misshapen puzzle. Flad had favored using a combination of cable tension and thermal contraction. On a cool day it ought to be possible to spring the arches far enough apart to fit the last rib section into place. Eads had disagreed, arguing that the ribs were too stiff to bend the needed inches. Before he left for Europe, Eads had suggested an

67. Eads, *Addresses and Papers*, pp. 77–88; William Taussig, "Personal Recollections of General Grant," *Collections of the Missouri Historical Society* 2 (1903): 10–12.

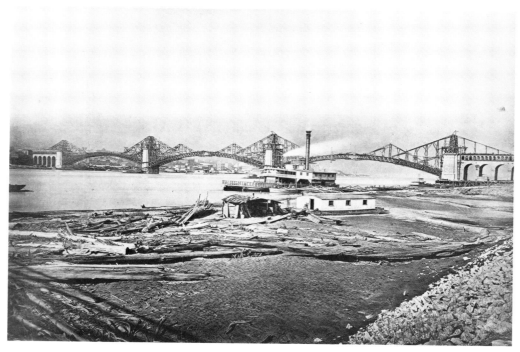
Closing the east and center spans, winter 1873. Robert Benecke, photographer.

alternative plan. He designed a special sleeve coupling with right- and left-hand threads cut in opposite ends. If the last two rib sections were cut slightly short and threaded to match the coupling, it might be possible to spring the arches, start the threaded coupling on each of the two rib sections, and screw the arch together with a giant wrench. The threaded center coupling would have the added advantage of allowing fine adjustments in the profile of the completed arch.[68]

On 12 September, after days of maneuvering the half-arches into alignment, Flad tried unsuccessfully to close the arch. Two days later he tried again, this time packing the ribs with nearly fifteen tons of ice in a futile attempt to shrink them. Time was running out; a needed half-million-dollar loan was contingent upon the first arch closing by the nineteenth. On the seventeenth, Flad finally bowed to Eads's judgment and closed the arch with the double-threaded coupling. It had been a tense and exhausting week. Cooper had been on the job for sixty-five hours straight. "We were

68. Woodward, *History of the St. Louis Bridge*, pp. 174–78.

so sleepy," he recalled, "that it was almost impossible to keep our eyes open, and I was much afraid that some of us would go into the river. Many of the men had left, and only about half a dozen remained to the last."[69]

The closing of the first arch had finally proved the feasibility of Eads's design. Work on the remaining ribs proceeded rapidly, facilitated by past experience and impelled by fiscal considerations. The bridge bonds would lapse and the company would run out of money unless all three spans were closed by 18 December. Working round-the-clock, Eads's men finished at 7:40 on the morning of the deadline day.

Once the arches were closed, the remaining construction work was relatively routine. Flad closed the outer ribs within a month. By the end of May 1874, the rail deck and upper roadway were nearly ready for traffic. On 18 April, Keystone announced that the bridge would open for pedestrian traffic the next day. During the night, however, Carnegie had second thoughts and decided that it would be prudent to hold the bridge as security until the bridge company settled its accounts. When eager St. Louisans arrived at the bridge the next morning, they found a section of the roadway ripped up and Carnegie's armed guards on the bridge. Fortunately, it was pouring rain, which kept the crowd small and probably prevented a riot. After another month of haggling, Keystone finally vacated the bridge on 23 May, and some twenty thousand visitors paid a nickel apiece (children under five were free) to be the first to promenade across the Mississippi.[70]

June witnessed a succession of load tests and the completion of the tunnel. Progressively heavier trains shuttled back and forth across the bridge as Eads and his staff took meticulous measurements. The general public was probably more reassured, however, by a nonscientific test on the fourteenth. Everyone knew that elephants had canny instincts and would not set foot on an unsound bridge. The crowd cheered as a great beast from a local menagerie mounted the approach without hesitation and lumbered placidly across to the Illinois side.[71]

The grand-opening celebration took place on the Fourth of July. Although it was an oppressive St. Louis summer day, close, humid, with the temperature standing at 102°, thousands of citizens and visitors turned

69. Ibid., p. 177.
70. *St. Louis Republican*, 23 May 1874.
71. *St. Louis Republican*, 15 June 1874.

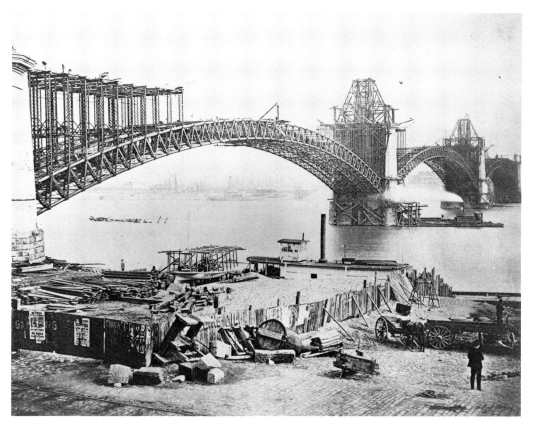
Beginning construction of the road deck, spring 1874. Robert Benecke, photographer.

out for the festivities. A sizeable portion of the community must have participated in the fourteen-mile-long parade. At the dedication ceremonies, local politicians and bridge promoters indulged in an afternoon of florid Victorian oratory. True to form, James Eads delivered a brief address that could be read either as polite self-effacement or as supreme self-congratulation. He took pains to praise his associates and portrayed himself as the mere representative of a "community of earnest men, whose combined labor, brains and wealth, have built up this monument of usefulness for their fellow-men." At the same time, he reiterated his abiding faith in the absolutes of engineering, his conviction that failure was impossible for those who lived by immutable natural laws. "Yesterday friends expressed to me their pleasure at the thought that my mind was relieved after testing the

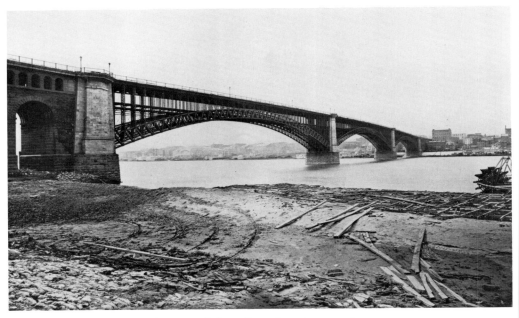

Eads Bridge completed, July 1874. Robert Benecke, photographer.

bridge," he declared. "But I felt no relief, because I had felt no anxiety on the subject." "Yon graceful forms of stone and steel," he added, would endure as long as the pyramids.

For anyone who believed in omens, the most significant event of the celebration was yet to come. The grand finale was to be a fireworks display on the bridge that evening, climaxing in a pyrotechnic "phantom train" whose illuminated engine and cars would run the full length of the bridge. The display fizzled.[72]

* * * * *

The phantom train seemed to cast its shadow over the subsequent history of the bridge. In that story James Eads played little part; with hardly a backward glance he was off on his next great enterprise, building jetties at the mouth of the Mississippi. In the flush days of '68, success had seemed

72. Eads, *Addresses and Papers*, pp. 42–45; Kouwenhoven, "Eads Bridge: The Celebration," pp. 159–95.

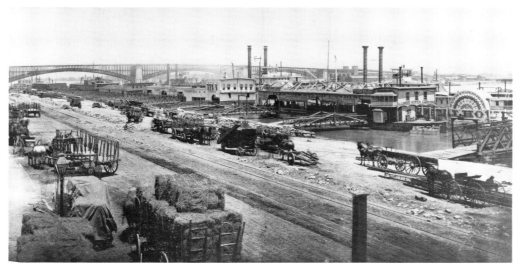
Eads Bridge from the levee, ca. 1890. Photographer unknown.

inevitable. "It is barely possible for the mind to keep within cool, calculating bounds when contemplating the future of St. Louis," he had written. "The construction of this Bridge will stimulate the production and fabrication of iron, encourage the erection of manufactories of all kinds, and invigorate the whole industrial and commercial life of the city."

The bridge never lived up to Eads's expectations. It did not generate anticipated tolls, nor did it revitalize the St. Louis economy or enable the city to regain dominance over midwestern trade. Instead, it fell easy victim to the Gilded Age preference for short-run speculative profits over long-term returns. Overcapitalized, it was burdened from the outset with debts that made successive bond issues increasingly harder to sell, particularly after the Panic of '73 had demonstrated the dangers of being caught short. Above all, the bridge failed because the very railroads it had been built to serve would not let it succeed. The directors of the lines served by the bridge purchased controlling interests in St. Louis ferry and drayage firms and re-routed freight away from the bridge. Only a trickle of traffic crossed the train deck during its first year. Average daily railroad tolls amounted to a mere $163.30, scarcely more than the receipts from pedestrian traffic.

Lack of adequate terminal facilities also prevented full use of the bridge. The train deck was useless unless it linked the eastern and western

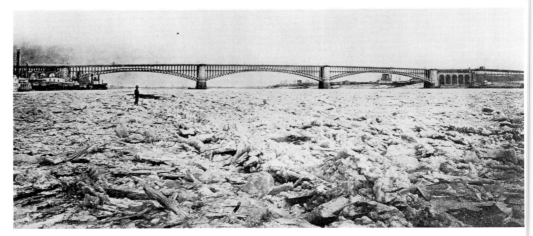

Eads Bridge in winter. Date unknown. Photographer unknown.

railroads converging on St. Louis. Yet it appeared in retrospect that even Eads had become so preoccupied with the structure itself that he forgot that it was only part of a larger transportation scheme. When the bridge opened in 1874 only one eastern line—the St. Louis, Vandalia and Terre Haute—had tracks running to the bridge. No other arrangements had been made to connect the bridge to the freight yards sprawling on the Illinois side. Moreover, except for occasional passing references to a projected St. Louis union station, it had never been clear what was supposed to happen once a westbound train reached the end of the tunnel, nor indeed how an eastbound train was to reach it at all. Several western lines already had separate stations in the city, and they showed little inclination to run connecting tracks to the mouth of the tunnel. Travelers passing through St. Louis found their way from railroad to railroad as best they could. Several proposals for a union depot surfaced from time to time after 1870, but none was built until 1875. Only in the 1890s would the Terminal Railroad Association finally organize the snarl of competing lines into a coherent and interconnected terminal system.[73]

73. Eads, *Addresses and Papers*, pp. 535–36; Illinois and St. Louis Bridge Company, *President's Report to Stockholders at Their Annual Meeting, held May 7, 1873* (St. Louis, 1873), pp. 1–7; Illinois and St. Louis Bridge Company and St. Louis Tunnel Railroad Company, *Annual Report, May 1875* (St. Louis, 1875), pp. 1–8; Taussig, *Development of St. Louis Terminals*. For convenient indexes of St. Louis economic life after 1866, see St. Louis Merchants Exchange, *Annual Statement of the Trade and Commerce of St. Louis* (St. Louis, 1866–?).

In April 1875, less than a year after the grand-opening celebration, Eads Bridge was bankrupt. To satisfy the principal bondholders (many of the original stockholders had long since been wiped out), in December 1878 the bridge was sold at public auction on the front steps of the court house. Although he was in St. Louis at the time, James Eads apparently did not attend the sale, so he was spared the pain of seeing his greatest engineering accomplishment go under the gavel for a mere $2 million, less than a third of its cost.[74]

The auction was actually a mere fiscal convenience, contrived under liberal bankruptcy laws to discharge some debts entirely, consolidate others, and concentrate control of the bridge into a few hands. The $2 million offer was the sole bid, tendered by the agent of the newly chartered St. Louis Bridge Company. Although a few of Eads's old friends were on the board of directors to represent a token St. Louis interest, controlling ownership rested in the hands of the New York and London bondholders, whose main interest was to play the bridge as a pawn in the game of international finance. Two years later, the bridge passed to the Terminal Railroad Association, a consortium organized by financier Jay Gould as part of his nearly successful scheme to monopolize the western railroads. After Gould's death in 1892, what was left of the fiscal structure remained with the TRRA, which, with responsible management, kept the bridge viable for another half-century.[75]

74. *Commercial and Financial Chronicle* 20 (5 June 1875):544; 27 (31 August 1878):227–28, and (27 October 1878):435. *St. Louis Globe*, 20, 21 December 1878; *St. Louis Bridge Company, Tunnel Railroad of St. Louis, and Their Leased Properties: Compendium of Charters, Acts, and Other Documents Relating to their Organization, 1864–1885* (St. Louis, n.d.), pp. 29–38. In 1868 Eads had projected the total cost of the bridge at $4,496,953. Woodward, *History of the St. Louis Bridge*, pp. 380–82, gives the as-built cost as $6,536,729.99, distributed as follows:

Superstructure	$2,122,781.65
Approaches	1,174,944.20
West Abutment	339,084.90
East Abutment	664,130.60
West Pier	463,712.67
East Pier	612,988.20
Equipment & Supplies	571,364.02
Engineers' Salaries	222,529.99
Misc. Expenses	360,193.76

75. *Commercial and Financial Chronicle* 49 (27 July 1889):115, and 49 (5 October 1889):435; *St. Louis Globe*, 21 December 1887; Julius Grodinsky, *Jay Gould: His Business Career* (Philadelphia, 1957), pp. 198–200, 338–41, 495, 527.

But the most careful management could not reverse the cumulative effects of passing time. A succession of rival downtown bridges, from the Merchants (1890) to the Poplar Street (1967), drained off traffic. Trains grew too heavy for the bridge, too big for the tunnel. The last train crossed the bridge in July 1974, exactly a century after Eads had declared that the bridge would remain "just so long as it continues to be useful to the people who come after us." With the trains only a memory and the tracks torn up, with vehicular traffic reduced to a trickle by competition from the free interstate-highway bridge, Eads Bridge became the haunt of pigeons and derelicts, a dingy old relic smelling of dust and river debris and ancient coal smoke. It was hardly noticed by the tourists who thronged to view Eero Saarinen's shimmering stainless-steel Gateway Arch. By the mid-1970s, the bridge was dead, the vitality of function gone.

* * * * *

What remained was the vitality of form and a dawning public recognition that whatever its economic shortcomings, Eads Bridge was a stunning technical and artistic achievement. In profile the bridge sat low to the water, its triple arches springing from the massive piers, the unbroken curve of the upper roadway spanning the river with economy and grace. It lacked the soaring quality of Roebling's more famous Brooklyn Bridge; from a distance stone and steel seemed to merge into an earthbound unity. Yet in its structure the poet Walt Whitman had found "perfection and beauty unsurpassable." Architect Louis Sullivan drew lifelong inspiration from its "sensational and architectonic" wedding of idea to actuality, form to function.

Bridges are peculiar structures in which architecture necessarily bows before the imperatives of engineering. A bridge may be monumental in scale and in visual effect, but it is not a building, nor does it follow the logic of structures built to enclose and define space. A building is a means to an end; its reality is the space inside. A bridge, in contrast, does not enclose space; it obliterates space by spanning a void. The reality of a bridge is the structure itself. Simple lines of force, vectors of tension and compression, dictate its fundamental form. The art of bridge design involves making manifest the beauty latent in the chosen form and the chosen material. The problem of bridge design lies primarily in the integration of dissimilar

forms and materials, each of which calls for its own suitable expression. However pleasing the geometry of their superstructures, most truss bridges still perch awkwardly on their piers. Suspension spans seldom resolve the conflict between the mass of their fortresslike towers and the aerial lightness of their catenary cables.[76]

Eads Bridge is an exception, for it displays a coherence rare in nineteenth-century American bridge design. Eads's decision to use steel in compression—to use it in the manner of stone—was prompted by considerations of economy and strength of materials. But the incidental effect was to mate span to pier in a natural harmony of strength, mass, and movement. The springing arches introduced a sense of vitality into the otherwise static granite, while the piers and abutments subdued but did not stifle the normally lively form of the upright arch.

James Eads rarely discussed the aesthetic aspects of his work. Unlike Roebling, who was given to artistic musings, Eads seldom strayed far beyond the hard facts of technology and economics. When he did speak of art, it was usually in the context of some tangible engineering or economic advantage. "We are too prone to associate our contemplation of the beautiful in architecture and engineering with the idea of costliness," he wrote in 1868, justifying his design to the stockholders. "It is easy to prove . . . that in no other form could the material in those members of your Bridge which impart to it the chief feature of its gracefulness, be used with such economy."[77]

Eads was nonetheless a conscious artist, one whose concern for architectural effect was scarcely less than his concern for engineering efficiency. The redesigning of the bridge between 1868 and 1870 illustrated the close interdependence of technical and artistic motives. The original design had incorporated two nine-inch ribs placed side by side. The versed sine, or rise, of the arches required the railroad tracks to approach the bridge at a relatively steep grade, while the horizontal train deck itself passed

76. Walt Whitman, "Specimen Days: Nights on the Mississippi," in *The Complete Works of Walt Whitman*, ed., Richard M. Bucke et al., 10 vols. (New York, 1902), 4:282–83; Louis H. Sullivan, *The Autobiography of an Idea* (New York, 1956), p. 247; Elizabeth Mock, *The Architecture of Bridges* (New York, 1949), pp. 7–11, 41–45.

77. Eads, *Addresses and Papers*, p. 511. Cf. Allan Trachtenberg, *Brooklyn Bridge: Fact and Symbol* (New York, 1965).

eight feet below the crown of the lower arch. Eads almost immediately realized that these features, not to mention George Barnett's embellishments, constituted bad engineering and bad architecture. The double rib was too complicated, the railroad gradient too steep. By cutting below the crown of the arch, the rail deck destroyed the otherwise graceful symmetry of the lower chord.

At considerable effort and expense (the changes called for entirely new calculations and new drawings), Eads redesigned the bridge. He recast the arches to "improve the architectural appearance of the bridge and simplify its fabrication." He replaced the smaller double ribs with large single ribs, thus simplifying the structure and heightening the visual effect by emphasizing the elemental form of the arch. He raised the rail deck four feet and lowered the rise of the center arch the same amount, so that the train deck met the arch at its crown. In order to reduce the railroad gradient, Eads also lowered the side spans eighteen inches while leaving the springing lines at the piers unchanged. The overall effect was to lower and smooth the profile of the arches and to transform the train deck from a stark horizontal line into a pleasing parabola. "Raising the tracks to the height of the centres of the arches," he wrote, "will unquestionably improve the appearance of the structure, and it is generally conceded that the alteration in the level of the springing of the shore ends of the side spans is likewise an architectural improvement. The effect upon the eye caused by it, will be somewhat similar to that produced by the camber of the Bridge."[78]

Although Eads had often delegated considerable responsibility to his assistants, in this case he worked almost alone. Stripped of its earlier frills, the bridge now depended entirely upon its form. Eads worked for months meticulously proportioning the various elements. The bridge would have been just as serviceable with three spans of equal width, yet the extra eighteen feet in the center span gave the bridge a central visual focus. At one point Eads even slimmed the piers by several feet over the vigorous protests of Charles Pfeifer, who feared that artistry had compromised sound engineering. In its final form, the bridge was a model of elegant simplicity. There were no contrived surface textures, no fancy ironwork, no decorative bolt heads or fussy cornices or gargoyles or statuary or sculptured effects. The

78. Eads, *Addresses and Papers*, pp. 577–78.

capitals of the piers and abutments were understated and stopped below the upper roadway so as not to break the line of the crown. George Barnett's arcaded approaches remained, but without their embellishments they now displayed a timeless classicism that complemented the overall design.[79]

Eads's design stood in striking contrast to the fashionable architecture of his day. Simplicity of expression in any medium was an accomplishment in the Gilded Age, an era that thrived on ostentation. What passed for elegance was often a frenzied eclecticism, a riot of mansard roofs and Gothic gingerbread, Italianate towers and bric-a-brac and filigree and cast-iron floral displays. Fortunately, Eads ignored the dictates of prevailing Victorian taste and resisted the urge to "improve" the useful with the beautiful.

His clean, fresh, and clearheaded sense of design flowed from the same sources as his inventive engineering. The bridge was a masterful example of what art historian Herwin Schaefer has called "nineteenth century modern," a functional tradition in design that coexisted with the fussier and more familiar "Victorian" style. The functional tradition never enjoyed the sanctions of polite respectability and remains even today seriously underrepresented in museums and galleries. Yet it was, if anything, closer to the real dynamics of Victorian culture than were the overstuffed parlors of the upper middle class.[80]

The functional tradition thrived in the realm of technology and everyday living, outside the confines of formal art and architecture. It found expression in the simple elegance of scientific instruments and machine tools, in the efficient design of factories and steam engines, carriages and ships. It also existed in the vernacular, in unassuming and commonplace tools, utensils, and furniture whose forms had evolved during centuries of intuitive adaptation to function. Rooted in the experience of artisans and mechanics, transmitted by example, the functional tradition did not become a formal and self-conscious style until the twentieth century. In James Eads's day it was still a matter of inarticulate shop practice. William Sellers, master machinist and president of the Midvale Steel Company, captured its es-

79. Carl Gayler, "Bridge Designing," *Journal of the Association of Engineering Societies* 42 (March 1909):113–14; Gayler, "Engineering History of St. Louis," pp. 6–7, 14–15.

80. Herwin Schaefer, *Nineteenth Century Modern: The Functional Tradition in Victorian Design* (New York, 1970). Cf. John A. Kouwenhoven, *The Arts in Modern American Civilization* (New York, 1967).

sence when he insisted that any machine that worked right would look right.[81]

Sellers's principle of fitness was hardly an adequate basis for a satisfying aesthetic theory, since two objects might be equally useful without being equally pleasing. But it did have a substantial foundation in nineteenth-century thought. In the twentieth century, it would find secular expression in the functionalism of the Bauhaus. But in Victorian America, functionalism was still organicism, and that made it a branch of piety. Men like Sellers and Eads still believed that the true, the useful, and the beautiful were equally manifest in the harmony of creation. Machines that worked right looked right because utility and taste were one in the mind of God.

Practitioners of the functional tradition rarely articulated its theory. The clearest discussions usually came from offbeat architects, literary critics, and artists with a philosophical turn of mind. Eads would have found the writings of sculptor Horatio Greenough particularly appealing. Like Eads, Greenough understood the unity of the organic and the mechanical and saw in architecture an opportunity to express symbolically the values of a democratic and technological culture. In 1852, Greenough had published a slim volume of aesthetic criticism titled *The Travels, Observations, and Experiences of a Yankee Stonecutter*. Ralph Waldo Emerson, impressed by Greenough's ideas, had broadcast them to an even wider audience.

Greenough was reacting against mid-Victorian clutter, against a fawning classicism that encouraged Doric farmsteads and Gothic steamboats. He believed that the dead hand of European culture was stifling spontaneous American expression, that mimicry and ostentation only obscured the simplicity of artistic truth. Greenough reminded Americans that "there is not one truth in religion, another in mathematics, and a third in physics and art; but that there is one truth, even as one God, and that organization is his utterance." God spoke most plainly through the forms of living things.

81. For examples of Sellers's work, see the remarkably early photographic illustrations to Wm. Sellers & Co., *A Treatise on Machine Tools, Etc., as Made by Wm. Sellers & Company* (Philadelphia, 1873). See also "Modern Architecture: The Office of Art in Engineering," *Van Nostrand's Engineering Magazine* 2 (February 1869):148–49; Coleman Sellers, "A Tribute to Alexander Lyman Holley," *Transactions of the American Society of Civil Engineers* 3 (1882):65–66. The best discussions of the functional tradition are Schaefer, *Nineteenth Century Modern*; Kouwenhoven, *The Arts in Modern American Civilization*; and Sigfried Giedion, *Mechanization Takes Command* (New York, 1948).

All of animate Nature revealed the same principle, "the principle of unflinching adaptation of forms to functions." The streamlined efficiency of the eagle in flight represented the aesthetic ideal.

Man best approximated the divine by applying the same principles through the practical arts. The Yankee Clipper was beautiful because it was functional. Bridges and similar works of scientific engineering were pleasing because the "stern organic requirements" of function reinforced the elegance of mathematics.[82]

James Eads may never have read Horatio Greenough, nor did he adorn his talk with references to aesthetic theory. Nevertheless, he shared Greenough's vision and through his bridge rendered that vision tangible for others to share. Yet most people would never see the best of James Eads's art. His most intriguing surprises were hidden away inside his bridge, visible only to trainmen and gandy dancers. It was perhaps fitting that workingmen should be in the best position to enjoy the artistry of a self-made engineer. The bridge was hardly visible at all to those who crossed on the upper deck. Tourists who viewed it from the levee could not imagine the mystery and drama of the interior. For Eads Bridge has an inside; the solid upper deck forms the ceiling of a vast room that does define and enclose space. The bridge is "sensational and architectonic."

From the outside the bridge dwarfs human scale. Once inside, the scale remains impressive but the effect changes. Structural details become accessible; the bridge grows dramatically intimate as it plays on all the senses. At the west abutment it assumes the aspect of a cave, while on the east it becomes a light and airy ballroom. Over the channel it becomes an endless corridor in which the curves of arch and roadbed play tricks with perspective and the sun casts shifting patterns of light and shade. The intricate linearity of the wind-truss and road-deck bracing provides a strong visual contrast to the sweep of the upper arches as they rise above the roadbed, then fall away in the distance. The textures of granite and steel convey a feeling of reassuring solidarity even on the dizzying catwalks, yet the whining wind and the sound of the current swirling against the piers are potent reminders that the bridge is under constant siege.

82. Henry Tuckerman, ed., *A Memorial of Horatio Greenough* (Boston, 1853), pp. 134–37, 172–74; Robert DeZurko, *Origins of Functionalist Theory* (New York, 1957), pp. 199–230.

Eads had closed his last report as chief engineer with the hope that the "great usefulness, undoubted safety and beautiful proportions" of the bridge would "constitute it as a national pride, entitling those through whose individual wealth it has been created to the respect of their fellowmen; while its imperishable construction will convey to future ages a noble record of the enterprise and intelligence which mark the present times."[83] If history dashed some of his hopes, it more than fulfilled others. The bridge became a milestone in the history of engineering, its builder an inspiration to generations who sought to follow his example of self-made manhood. As building art, the bridge symbolized the triumphant convergence of steam and steel in nineteenth-century America. It was the proud product of a Victorian age that could worship both God and science. No other undertaking of America's centennial decade, except perhaps the great Corliss engine at the Philadelphia Exposition in 1876, incorporated so well the best the nation had to show in business enterprise, technical sophistication, and functional design. A century later it still stood, a monument to what Louis Sullivan had called "the will of the Creative Dreamer," the almost mystical vision and power that enabled some men to transform even unorthodox ideas into realities.

83. Eads, *Addresses and Papers*, p. 599.

Index

A

Arch bridges. *See* Bridges: arch

B

Barnett, George I., 78, 79n, 90, 130–31
Bates, Edward, 68
Baur, Julius, 109–10
Belknap, William, 119–20
"Bends," The. *See* Caisson Disease
Boomer, Lucius, 73–76, 79, 90–91
Bridges: arch, 82–87; as architecture, 128–29; long-span railroad, 80, 85; suspension, 73; truss, 76, 80–82, 85–86
Bridges, specific: Britannia (Wales), 73; Brooklyn (New York), 128; Cincinnati Southern (Ohio), 82; Cincinnati Suspension (Ohio), 73; Koblenz (Germany), 83–4; Merchants (Missouri), 128; Niagara (New York), 73; Poplar Street (Missouri), 128; Sunderland (England), 82
Butcher, William, 106, 107n, 110. *See also* William Butcher Steel Company

C

Caisson Disease, 68, 100–1
Caissons, 94–101
Carnegie, Andrew, 61, 92, 103–4, 112, 122
Carnegie Kloman & Company, 103, 105, 111–12
Chanute, Octave, 91
Charles River Bridge vs. The Warren Bridge, 71
Chase, Calvin, 64, 75
Chauvenet, William, 76
Chicago, Ill., 70, 72
Chrome steel. *See* Steel, chrome
Chrome Steel Company, Brooklyn, N.Y., 107, 107n, 108–10
Clemens, Samuel L., 63
Cofferdams, 91–92
Colburn, Zerah, 79
Cooper, Theodore, 91, 118, 120–21
Corps of Engineers, U.S. Army, 119–20

D

Douglas, Stephen A., 72
Dry, Camille, 90
Durfee, William, 110

E

Eads, James Buchanan: as architect, 129–31, 133; as engineer, 66–67, 84–91, 123–24; as entrepreneur, 74–75, 92; childhood and education of, 62; conception of engineering, 61–62, 102, 123–24; conception of nature, 61–62, 66–67; ill health of, 68–69, 91, 118
Eads, Martha (Mrs. James B.), 67–68
Eads Bridge: as architecture, 128–31; bankruptcy of, 127; cost of, 127n; dedication of, 122–23; design of, 76–77, 85–87, 90, 129–31; piers and abutments, 90–102; superstructure, 115–18, 120–22
East St. Louis, Ill., 70–71, 119
Emerson, Ralph Waldo, 132
Engineering, 79
Erie Canal, 70

F

Fairbairn, William, 89
Flad, Henry, 76, 91, 103, 110, 115, 117–22
Franklin, Benjamin, 82
Functional design, 131–33

G

Gateway Arch, 128
Gould, Emerson, 92
Gould, Jay, 127
Grant, Ulysses S., 119–20
Greenough, Horatio, 132–33

H

Homer, Truman, 73
Howe, Henry, 110–11, 111n
Humphreys, Gen. A. A., 119
Hydraulics, river, 63, 65–67, 79–80

I

Illinois and St. Louis Bridge Company, 73
Illinois Town. *See* East St. Louis, Ill.
Iron: as component of Eads Bridge, 103–4n, 111, 114–15; as structural material, 88–89

J
Jaminet, Dr. Alphonse, 101

K
Keystone Bridge Company, 61, 102–4, 110–11, 118, 122
Kirkaldy, David, 107n
Koblenz, 83–84

L
Laurie, James, 112–14
Lawrenceburg, Ind., 62
Lincoln, Abraham, 68
Linville, Jacob, 61, 103, 118

M
Mark Twain. *See* Clemens, Samuel L.
Metallurgy. *See* Iron; Steel, chrome; Steel
Midvale Steel Company, 110, 131
Mississippi Submerged Tubular Bridge Company, 73
Morgan, J. P., 92
Morgan, Junius, 92

N
National Museum of Transport, 111n
Nelson, William, 64, 68

P
Paine, Thomas, 82
Pfeifer, Charles, 76, 84, 91, 100, 130
Philadelphia Exposition, 1876, 134
Post, S. S., 74, 74n, 75
Pullman, George, 90

R
Railroads: as factor in economic development, 69–73, 125–26; Chicago and Rock Island R.R., 71; St. Louis, Vandalia and Terre Haute R.R., 126
Roberts, Dr. John, 111n
Roberts, Milnor, 91
Roebling, John A., 73, 128–29

S
Saarinen, Eero, 128
Saint Louis and Illinois Bridge Company, 73–75
Saint Louis Board of Trade, 74
Saint Louis Bridge Company, 127
Saint Louis Daily Democrat, 78
Saint Louis Merchants Exchange, 71, 74, 76
Sellers, William, 131–32
Solomon, Russell C., 111n
South Pass jetties, 66, 67n, 124
Steel: as structural material, 82, 87–90, 105; carbon, 106–7, 114; specifications for Eads Bridge, 89–90, 103–4n. *See also* Iron; Steel, chrome
Steel, chrome: Eads's use of, 105–11, 114; metallurgy of, 105–7, 107n, 109–11, 111n, 114, 116
Stephenson, Robert, 73
Sullivan, Louis, 128, 134
Suspension bridges. *See* Bridges: suspension

T
Taney, Roger B., 71
Telford, Thomas, 82–83
Terminal Railroad Association, 126–27
Travels, Observations, and Experiences of a Yankee Stonecutter. *See* Greenough, Horatio
Truss bridges. *See* Bridges: truss

U, V
Urban rivalry: St. Louis vs. Chicago, 70–72
Vollmar, Joseph, Jr., 111n

W
Washington University, 76
Wernwag, Louis, 82
Whitman, Walt, 128
Wiggins Ferry Company, 71, 73
Williams, Barrett, 62
William Butcher Steel Company, 105. *See also* Butcher, William